IMAGES
of America

GEORGIA
AND THE POWER
OF THE VOTE

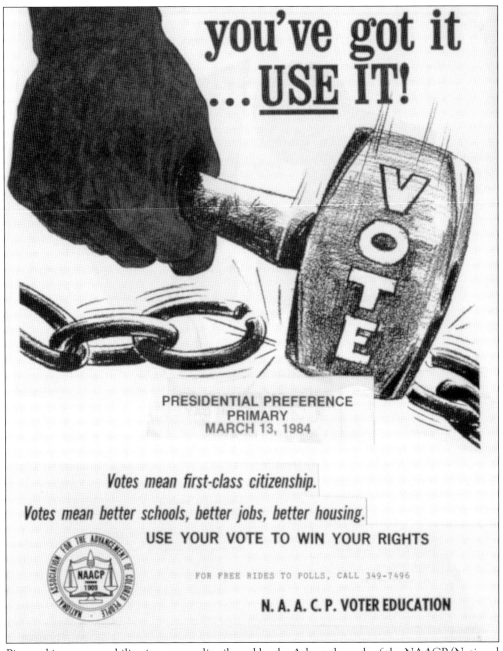

Pictured is a voter mobilization poster distributed by the Atlanta branch of the NAACP (National Association for the Advancement of Colored People) encouraging Georgians to participate in the presidential primary election on March 13, 1984. (Courtesy of the Auburn Avenue Research Library.)

ON THE COVER: An Atlanta University Center student is photographed protesting against Rich's department store in Atlanta, Georgia, for their engagement in Jim Crow practices. (Courtesy of the Library of Congress.)

IMAGES
of America

GEORGIA AND THE POWER OF THE VOTE

Karcheik Sims-Alvarado, PhD

ARCADIA
PUBLISHING

Copyright © 2024 by Karcheik Sims-Alvarado, PhD
ISBN 978-1-4671-0948-2

Published by Arcadia Publishing
Charleston, South Carolina

Printed in the United States of America

Library of Congress Control Number: 2023952172

For all general information, please contact Arcadia Publishing:
Telephone 843-853-2070
Fax 843-853-0044
E-mail sales@arcadiapublishing.com
For customer service and orders:
Toll-Free 1-888-313-2665

Visit us on the Internet at www.arcadiapublishing.com

This book is dedicated to the lesser-known victims, documented in this book, who were intimidated or killed in pursuit of exercising their constitutional right as citizens of the United States: the "33 Original" Black Georgia legislators, George Ashburn, Leo Frank, George Dorsey, Mae Murray Dorsey, Dorothy Malcom, Roger Malcom, Maceo Snipes, Isaiah Nixon, and Dr. Thomas Brewer. This book is also dedicated to my second great-grandfather Thomas English, a former slave who voted in Georgia for the first time as a freedman in 1867. Finally, I thank my husband, Joel Alvarado, and son, Nation, for offering support and encouragement as I pushed to write this very challenging narrative of Georgia's history.

Contents

Acknowledgments		6
Introduction		7
1.	The Prelude: Hurrah! Hurrah! We Bring the Jubilee!	9
2.	The First Wave: Reconstruction, Representation, and Retraction, 1865–1877	15
3.	The Second Wave: Birth of Jim Crow, Birth of a Nation, 1895–1948	49
4.	The Third Wave: Jim Crow Must Go, 1960–2010	99
5.	The Fourth Wave: A Blue Island in a Red Sea, 2020–2023	119

ACKNOWLEDGMENTS

Georgia has a violent history. Writing about the pursuit of those to secure political power while denying others the right to vote in Georgia was very emotional and grueling. It is one of the more challenging histories I have had to document.

The majority of the images for this project were made possible through the generous support of the Library of Congress, the Associated Press, the New York Public Library, the Herndon Home Museum, Auburn Avenue Research Library, the Breman Museum, the A.U.C. Robert Woodruff Library and Archives, the Georgia Archives, and other archives and museums throughout the state of Georgia.

I cannot thank enough my husband, Joel Alvarado. It is wonderful to have a life partner who believes in the promise of freedom as much as I do. To my creative son, Nation, you get to bear witness to what it takes to document history. Thank you both for being patient as I pushed myself, night after night, to produce this book.

Unless otherwise noted, all images are courtesy of the Library of Congress.

INTRODUCTION

This book traces the history of enfranchisement in Georgia and its influence on American politics and policy from 1865 to 2023. Since the close of the Civil War, Georgia's response to the vote has captured and maintained the nation's attention. During multiple waves, voter registration, mobilization, and suppression efforts were influenced by push-pull forces between those wanting to sustain power and those untiringly committed to acquiring it; those hoping to maintain the status quo and those steadfastly determined to disrupt it; and those trying to exercise their right to vote and those trying to suppress it. The historical tug-of-war between Georgians has consistently had national implications. The outcomes have shaped national policy, influenced landmark court decisions, ignited social movements, and produced national leaders.

At the end of the Civil War, land ownership and self-sufficiency were priorities for newly emancipated people. For example, freedmen from Savannah, Georgia, convinced Gen. Ulysses S. Grant to issue Special Field Order No. 15, which allowed for the redistribution of almost 400,000 acres of land to Black families along the South Carolina, Georgia, and Florida coasts. This desire for land surpassed any interest in securing suffrage rights. Their yearning for economic autonomy influenced US secretary of war Edwin M. Stanton to establish the Freedmen's Bureau, formally the Bureau of Refugees, Freedmen, and Abandoned Lands, to assist millions of newly freed people in making the transition from slavery to freedom. While the bureau provided medical treatment, education, rations, and clothing, it failed to offer Black families the land they desperately wanted. At least in Georgia, it successfully registered nearly 190,000 men as voters, of which more than 95,000 were African American. In response to federal efforts to assist formerly enslaved Africans in their transition to freedom, Southern Whites, primarily Democrats, launched a counter-offensive to regain political and economic power.

For the next 12 years, racial and political tensions in Georgia increased as Democrats used fear to intimidate Black and White Republicans. Those of the former Confederacy continued their pursuit to maintain White supremacy by securing elected positions, supporting domestic terrorism, and undermining all efforts by the federal government to usher in a new era of racial equality. During Reconstruction, there were significant achievements in American history: the passage of the 13th Amendment and the Civil Rights Act of 1866. Additionally, Blacks began to establish communities, organizations, and institutions. As freedmen, they exercised their voting rights for the first time in the American South.

Conversely, members of the White plantocracy began to reestablish organizations, institutions, and policies to undermine Black advancement. Central to this effort was the emergence of the Ku Klux Klan, founded in Georgia in 1868 with the murder of US Senate candidate George Ashburn, a White Republican. Three years after Emancipation, Democrats regained political power in Georgia by removing 33 duly elected Black state legislators from office and negotiating the freedom of George Ashburn's murderers in exchange for ratifying the 14th Amendment. The actions of Georgia Democrats led to Pres. Ulysses S. Grant pressing Congress to pass the 15th Amendment,

thereby codifying enfranchisement rights for Black men. Democrats won complete control of the region by negotiating the Hayes-Tilden Compromise of 1877 and removing all federal troops from the South. This act set the stage for unchecked violence toward Blacks in Georgia and silence from White Republicans who were previously allied to African Americans.

In the following two decades, African Americans experienced the "Nadir," the lowest point in American history. It was a time of extreme violence and the reversal of Black voting and civil rights from legislative and judicial fiat. Yet, it was also a time of Black perseverance and determination. Even as Booker T. Washington minimized the importance of equality and enfranchisement for Black people during his address before an interracial audience at the Atlanta Cotton State Exposition in 1895, Blacks began organizing voting mobilization campaigns. In response, White Democrats instituted segregation, validated by the Plessy decision and undergirded by racial violence to quash any effort towards equality. The anger and hatred of some Southern Whites was not solely aimed at Blacks. Other communities felt the sting of violence and intimidation. The trial and lynching of Leo Frank, a Jewish factory supervisor in Atlanta falsely accused of murdering a 13-year-old employee, resurrected the Ku Klux Klan in Georgia and maintained Democrats' political power in the state. Following World War II, a shift occurred. The rise of racial intimidation and discrimination in Georgia led to an alliance between African Americans, Jews, and Whites. Together, they organized to suppress White terrorist groups by using the courts and the vote. Following the landmark ruling in Primus King v. Chapman, African Americans could finally vote during the primary election, and they actualized the power of their vote and mobilization strength. Since 1948, Black voter participation in Georgia has determined the outcome of city, state, and national elections.

By the mid-20th century, a younger generation of activists emerged, seeking a more direct and radical approach to exercising their rights as full citizens. A culmination of the death of Emmett Till and the Brown decision fostered this paradigm shift by bringing attention to the safety and educational concerns specific to African American youth. Deploying direct-action tactics and invoking the language of civil and human rights, the energy and zest of this generation of activists pushed the modern civil rights movement into a new chapter where young men and women became the voice of social unrest. From 1960 to 1965, Black and White civil rights activists became the leaders of national civil rights organizations and pushed for the passing of the Civil Rights Act of 1964 and the Voting Rights Act of 1965. For the next 40 years, Georgia witnessed African Americans, Jews, Hispanics, Asians, and women belonging to the Democratic Party become legislators. However, by 2002, Georgia gradually returned to Republican rule.

Since 2018, Georgia has experienced significant political change with the emergence of BIPOC (Black, Indigenous, and People of Color) and women-led voter registration organizations across the state. Consequently, the state has moved closer to becoming purple. In 2020, Georgia witnessed a political shift when Democratic presidential nominee Joe Biden and his running mate Kamala Harris won Georgia while electing the first Jewish American and African American US senators to represent the "Peach" state. In response to this Democratic victory, Republicans in the 2021 Georgia General Assembly investigated the election and passed legislation reflecting their concerns. Also in 2021, former president Donald Trump alleged the 2020 election was stolen from him, leading to state and local investigations with no evidence to the allegation found. In 2022, Stacey Abrams again sought the governorship but was unsuccessful. Sen. Raphael Warnock was the only Democrat to win a statewide seat, defeating the Republican senate candidate Herschel Walker. The year 2023 found Georgia again in the national political discourse as former president Donald Trump faced numerous charges of illegally changing the 2020 election while still leading the polls in his bid to win the 2024 Republican presidential nomination.

One

The Prelude

Hurrah! Hurrah! We Bring the Jubilee!

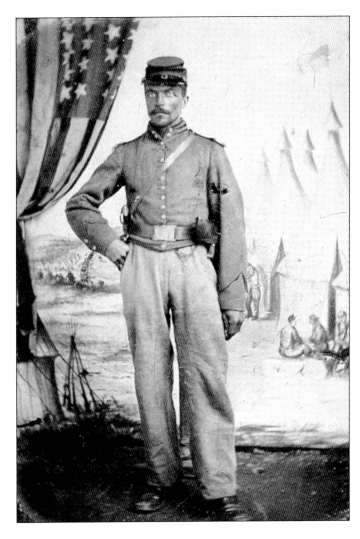

On May 7, 1864, Gen. William T. Sherman launched his crusade from Chattanooga to advance on Atlanta. Four months later, he captured the city. In October, Sherman informed Gen. Ulysses Grants of his "March to the Sea" campaign. He arrived at Savannah in December and forced the Confederate army to surrender in January 1865. Sherman's victories increased Union supporters' confidence that the end of the institution of slavery was near.

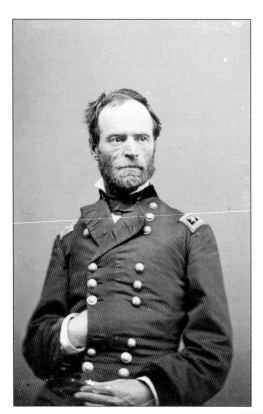

Closing the "March to the Sea" military campaign, Gen. William T. Sherman met with 20 Black ministers in the home of Charles Green in Savannah on January 12, 1865, to learn their position on the surest path for newly freed people to secure autonomy.

Accompanying General Sherman was US secretary of war Edwin M. Stanton, pictured here. Two months following the Savannah convening of Black ministers, he pressured Congress to establish the Bureau of Refugees, Freedmen, and Abandoned Lands.

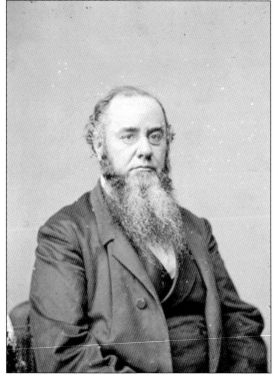

The committee of Black ministers who met with Gen. William T. Sherman and Sec. Edwin M. Stanton included Garrison Frazier, Ulysses Houston (right), and William Campbell (below). As a spokesman, Frazier declared, "The way we can best take care of ourselves is to have land and turn it and till it by our labor." Four days later, Sherman issued Special Field Order No. 15, allowing for confiscating coastal lands and redistributing those lands to formerly enslaved people from Charleston, South Carolina, to St. John's River, Florida. The Order redistributed 400,000 acres of land to African American families in 40-acre parcels. Upon Pres. Abraham Lincoln asking how freed people would plow fields with limited farm equipment, Sherman suggested each grantee receive an army mule. Over time, the Order was popularly called "Forty Acres and a Mule."

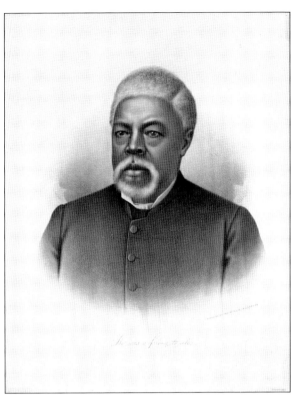

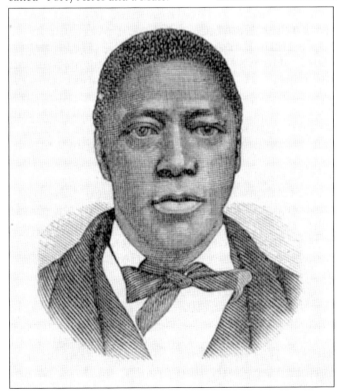

TO FREEDMEN.

SAVE YOUR MONEY!

Every Man, Woman and Child should put their money for

SAFE KEEPING,

AND

ACCUMULATION OF INTEREST,

INTO THE

Freedmen's Savings Bank,

BROAD ST., AUGUSTA, GA.,

HEADQUARTERS FREEDMAN'S BUREAU.

Deposits of One Dollar and upwards, received every day, from 12.30 to 3.30 P M.
These Deposits can be drawn out whenever the Depositor chooses.

☞ This SAVINGS BANK is a Branch of the National Freedman's Savings and Trust Company, chartered by Act of Congress, March 3d, 1865, and approved by the late President, Abraham Lincoln.

C. H. PRINCE, Cashier.

To be economically autonomous, freed people recognized the value of owning land and banking. On March 3, 1865, Congress approved the establishment of the Freedmen's Savings Bank to protect monies earned by African Americans. Branches were in Augusta, Savannah, and Atlanta.

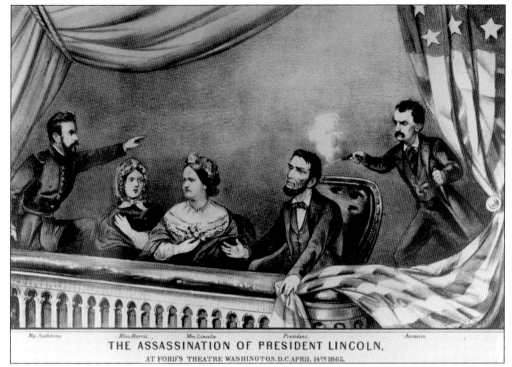

THE ASSASSINATION OF PRESIDENT LINCOLN.
AT FORD'S THEATRE WASHINGTON.D.C.APRIL 14TH 1865.

Robert E. Lee surrendered to Ulysses S. Grant on April 9, 1865. Five days later, Pres. Abraham Lincoln was assassinated by actor John Wilkes Booth.

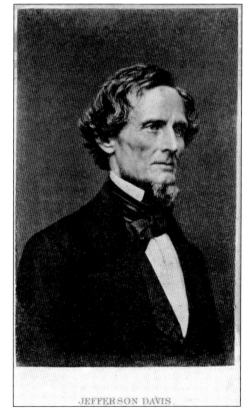

JEFFERSON DAVIS.

Confederate president Jefferson Davis was considered a suspect in the murder of US president Abraham Lincoln. After a three-week search, a Union cavalry of 128 soldiers and 5 generals seized and arrested Davis, who was found disguised as a woman while camping with his family in Irwinville, Georgia. For two years, he was imprisoned at Fort Monroe in Virginia.

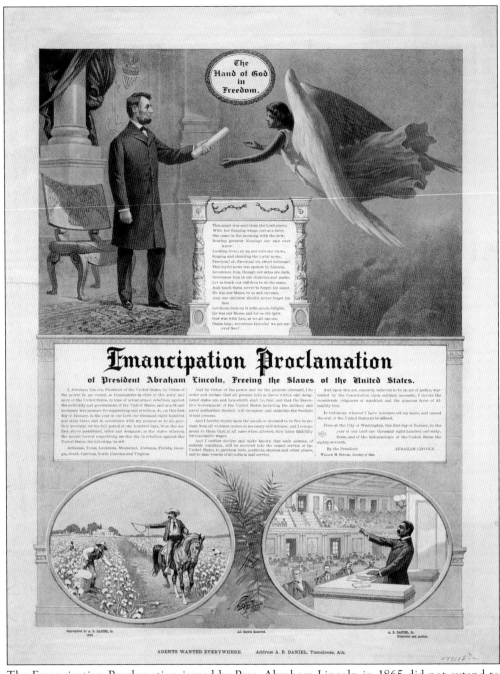

The Emancipation Proclamation issued by Pres. Abraham Lincoln in 1865 did not extend to enslaved persons in border states or the Confederacy. Congress passed the 13th Amendment on January 31, 1865, but approval from other states needed to come faster. Finally, on December 6, 1865, Georgia became the 27th state necessary for ratifying the 13th Amendment, which abolished slavery officially in the United States.

Two

THE FIRST WAVE

RECONSTRUCTION, REPRESENTATION, AND RETRACTION, 1865–1877

The Battle of Columbus ended the Civil War in Georgia when the Union destroyed a major Confederate manufacturing center on April 16, 1865. This event marked the end of slavocracy, but the planter class spent the next 12 years regaining political and economic power. However, their advances were matched by 460,000 newly freed Black Georgians ready to actualize their rights to own land, vote, and hold political office during Reconstruction.

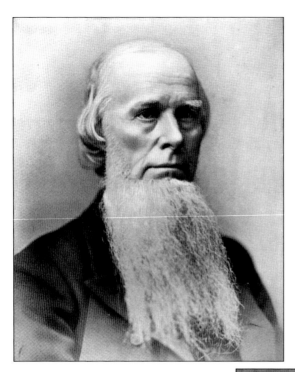

With Georgia now under Union authority, Gov. Joseph E. Brown was arrested and forced to resign. He was imprisoned in Washington, DC, for a short period. The once-slavocracy proponent received a pardon from Pres. Andrew Johnson and became a Republican chief justice of the Georgia Supreme Court.

Before the Civil War, James Johnson supported the Whig and Know Nothing Parties and rejected joining the widely supported Democratic Party. As a Unionist, Pres. Andrew Johnson appointed him as the first provisional governor of Georgia in June 1865, following the removal of Gov. Joseph E. Brown. (Courtesy of the Georgia Capital Museum.)

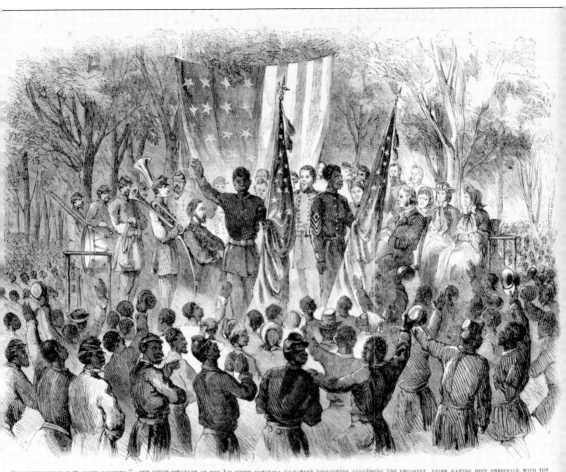

"EMANCIPATION DAY IN SOUTH CAROLINA."—THE COLOR-SERGEANT OF THE 1ST SOUTH CAROLINA (COLORED) VOLUNTEERS ADDRESSING THE REGIMENT, AFTER HAVING BEEN PRESENTED WITH THE STARS AND STRIPES, AT SMITH'S PLANTATION, PORT ROYAL ISLAND, JANUARY 1.—FROM A SKETCH BY OUR SPECIAL ARTIST.—SEE PAGE 275.

Under the Reconstruction Acts, the US Army's presence was obligatory if peace were to be maintained during the postwar period. Social change was inevitable and occurred quickly. Georgians were surprised to learn that Black soldiers would serve as members of the military. On June 16, 1865, the *Daily Constitutionalist* reported the arrival of the 33rd US Colored Troops to Augusta, Georgia.

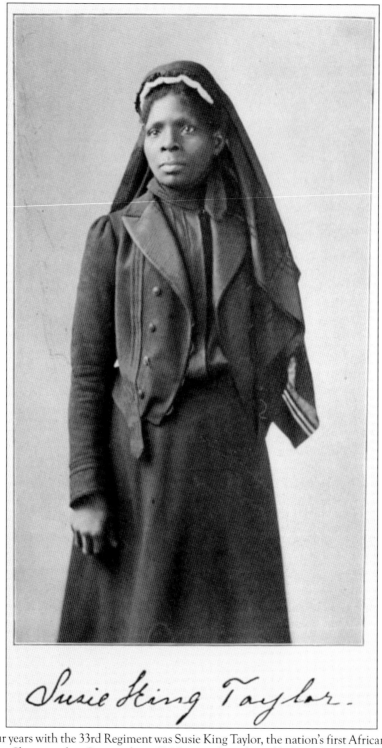

Serving four years with the 33rd Regiment was Susie King Taylor, the nation's first African American Army nurse. She moved to Savannah in 1866 to teach and establish a school for freed children without support from the Freedmen's Bureau.

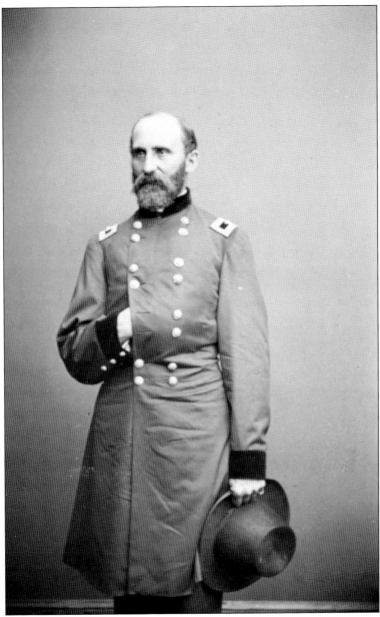

On March 3, 1865, the Freedmen's Bureau was established to provide aid to newly freed persons and poor Whites following the Civil War. Two months later, Gen. Rufus Saxton was appointed as assistant commissioner of the bureau overseeing Georgia, South Carolina, and Florida. Freed people refused to return to agricultural labor and demanded land. Saxton agreed, and as he stated two years earlier, "Give the negroes a right in that soil to whose wealth they are destined in the future to contribute so largely, to save them from destitution, to enable them to take care of themselves." In any case, Saxton encouraged freed people to labor and pleaded, "Labor is ennobling character, and if rightly directed, brings to the laborer comforts and luxuries of life. . . . If you do not obtain rights this year, be content with part, and if you act rightly all will come in good time." Black Georgians stood firm in their position. Saxton acquiesced and worked to protect properties granted under Special Field Order, No. 15. Consequently, he was fired by President Johnson.

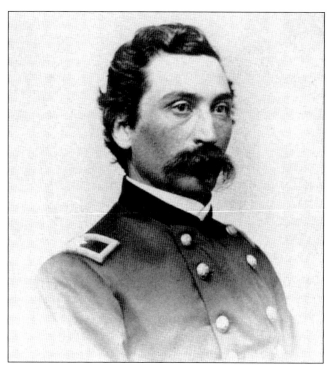

On September 22, 1865, Gen. Davis Tillson (left) replaced Gen. Rufus Saxton as assistant commissioner of the Freedmen's Bureau, representing Georgia, South Carolina, and Florida. Tillson was heavily criticized for his abusive power and for restricting the distribution of rations and other federal aid to newly freed people. Also, he pressured African Americans to work as field laborers for planters who were former enslavers. Tillson issued the threat that if Blacks did not secure work, they would be arrested and sentenced to perform hard labor. Four months later, he was replaced by Col. Caleb C. Sibley, whose successor was Maj. John Randolph Lewis (below).

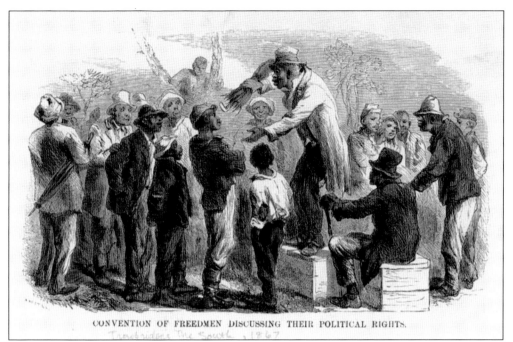

CONVENTION OF FREEDMEN DISCUSSING THEIR POLITICAL RIGHTS.

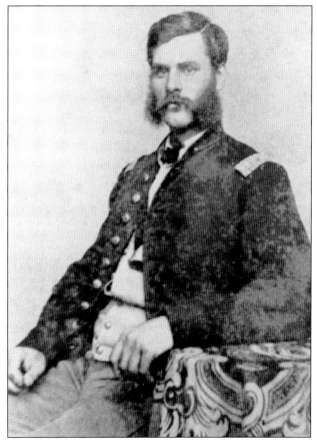

Ratified on December 6, 1865, the 13th Amendment abolished slavery in the United States. Freed people immediately began working to secure citizenship and voting rights. Their self-organizing spirit at the close of the war ignited the first wave of the long civil rights movement. On January 10, 1866, Black and White Georgians convened at Springfield Colored Baptist Church in Augusta to attend the Georgia State Freedmen's Convention. The name of the multiracial convention was changed to the Georgia Equal Rights Association and Capt. John Emory Bryant (right) was elected as president. The second convention was held on April 4, 1866, the first anniversary of Pres. Abraham Lincoln's death. Five days later, Congress passed the Civil Rights Act of 1866. The act set the stage for the Freedmen's Bureau to register Black men as voters throughout the South. (Above, New York Public Library; right, Duke University Library.)

Four months following the ratification of the 13th Amendment, Congress passed the Civil Rights Act of 1866. The act was the first federal law to define citizenship and declare racial discrimination or the denial of citizenship illegal. It declared, "All persons within the jurisdiction of the United States shall have the same right in every state and territory to make and enforce contracts, to sue, be parties, give evidence, and to the full and equal benefit of all laws and proceedings for the security of persons and property as is enjoyed by White citizens, and shall be subject to like punishment, pains, penalties, taxes, licenses, and exactions of every kind, and to no other." President Johnson vetoed the bill, but two-thirds of the House and Senate voted for the act to become law on April 9, 1866. (Newspapers.com.)

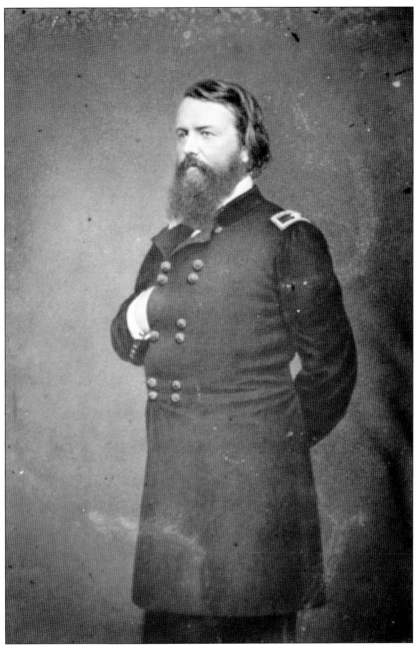

Reconstruction was first conceived and implemented by the Union army. The Reconstruction Act of 1867 outlined the terms for readmission to the Union. Under the governance of the US Army, the War Department divided the South into five military districts. The Third Military District, comprised of Georgia, Florida, and Alabama, was headquartered in Atlanta. Its fort, named after Gen. James B. McPherson, was established by the US Army in Atlanta in September 1867. The first commander of the district was Gen. John Pope (pictured). He was credited with registering 80 percent of all adult males as voters. To ensure Black men were enfranchised, he demanded that one of every three federal agents be Black. Pope's eight-month tenure was short-lived in Georgia. He was removed by Pres. Andrew Johnson on December 28, 1867, and replaced by Gen. George Meade.

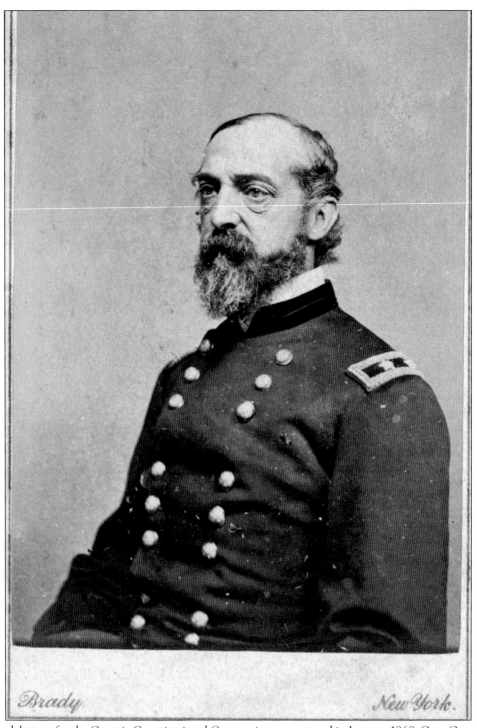

As delegates for the Georgia Constitutional Convention reconvened in January 1868, Gen. George G. Meade (pictured) was assigned by Pres. Andrew Johnson to ensure Georgia was readmitted into the Union. This required Georgia to adopt a state constitution, enfranchise Black men, and adopt the 14th Amendment for readmission into the Union.

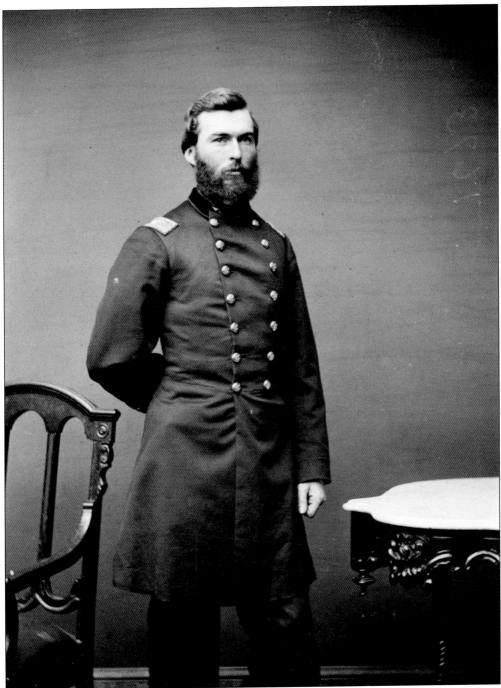

Gov. James Johnson refused state funds for the upcoming constitutional convention allowing for a racially integrated body of delegates to be held in Milledgeville, Georgia, the capital of Georgia at the time. It was ordered that the US military supervise the convention. Governor Johnson was removed by Colonel Meade, and Maj. Gen. Thomas Howard Ruger (above) was appointed as the new military governor of Georgia. Like those before him, Ruger's term was short and ended on July 4, 1868.

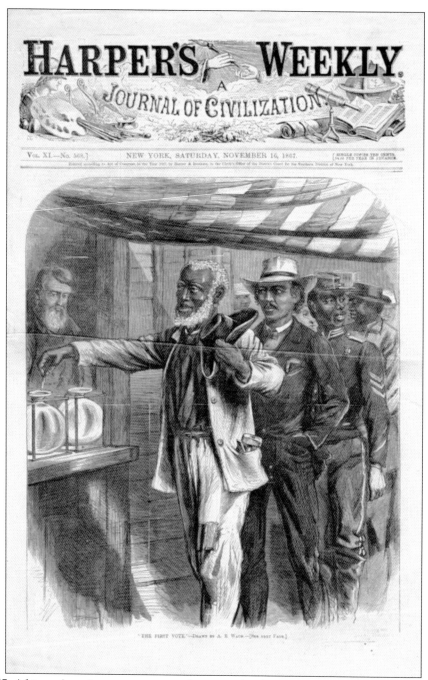

In 1867, African American men registered to vote for the first time in the American South. According to the secretary of war, federal agents of the Freedmen's Bureau registered 188,671 male voters to determine the creation of a new state constitution, to call a convention, and to elect state delegates. Over 93,000 of the registered voters were newly freed. From October 29 to November 1, 1867, a total of 96 percent of voters cast their support for a new constitution. However, the turnout amongst White registered voters was less than 40 percent. Of the 169 delegates elected to the Georgia Constitutional Convention, 37 were African American Republicans.

The Freedmen's Bureau originated the Bureau of Civil Affairs to undertake a massive registering campaign across the South. In Georgia, 52 Black men served as federal agents in the summer and fall of 1867 to register over 95,000 White and over 93,000 African American men. Tunis Campbell (pictured), a minister in the African Methodist Episcopal Zion Church, served as a registrar for the Freedmen's Bureau.

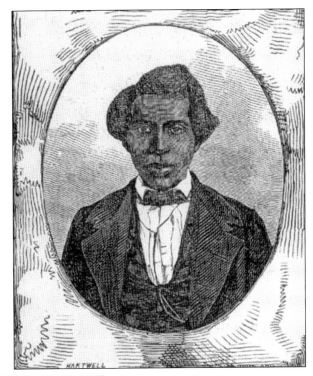

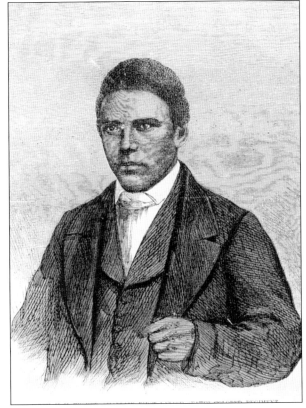

Pres. Lincoln appointed Rev. Henry McNeal Turner (pictured) as the first African American chaplain in the US Colored Troops. Born in South Carolina, he moved to Macon to serve as an agent for the Freedmen's Bureau in Georgia. Reverend Turner was celebrated as a Republican leader because of his statewide voter mobilization and recruitment success.

At 32 years old, formerly enslaved Thomas English of Oglethorpe, Macon County, Georgia, signed an oath of alliance and was recorded as a registered voter on June 29, 1867. He was one of 93,000 freedmen who voted for the first time in Georgia's history. Thomas English is the author's second great-grandfather. (Ancestry.com.)

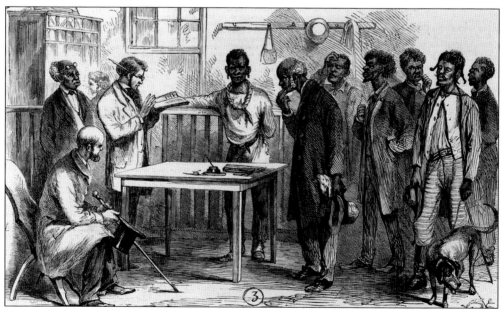

Featured in *Frank Leslie's Illustrated Newspaper* on November 30, 1867, artist James E. Taylor illustrated freedmen in Macon, Georgia, proactively registering to vote following the passage of the Civil Rights Act of 1866.

The Georgia Constitutional Convention was from December 9, 1867, to March 11, 1868. Of the 169 delegates elected, 37 were African American. In response to Gov. James Johnson refusing hotel accommodations in Milledgeville to Black delegates, the convention was held in Atlanta at the old city hall pictured. As a more welcoming city to African Americans, Atlanta would become the new state capital. A few of the 37 Black delegates and the counties they represented were Simeon Beard (Jefferson), Aaron Alpeoria Bradley (Chatham), Tunis Campbell (Liberty and McIntosh), Malcolm Claiborne (Burke), William Henry Harrison (Hancock), Philip Joiner (Dougherty), George Linder (Laurens), Robert Lumpkin (Macon), Romulus Moore (Columbus, Alexander Stone (Jefferson), Alexander Sone (Jefferson), Henry McNeal Turner (Bibb), George Wallace (Baldwin, Hancock, and Washington), and Samuel Williams (Harris).

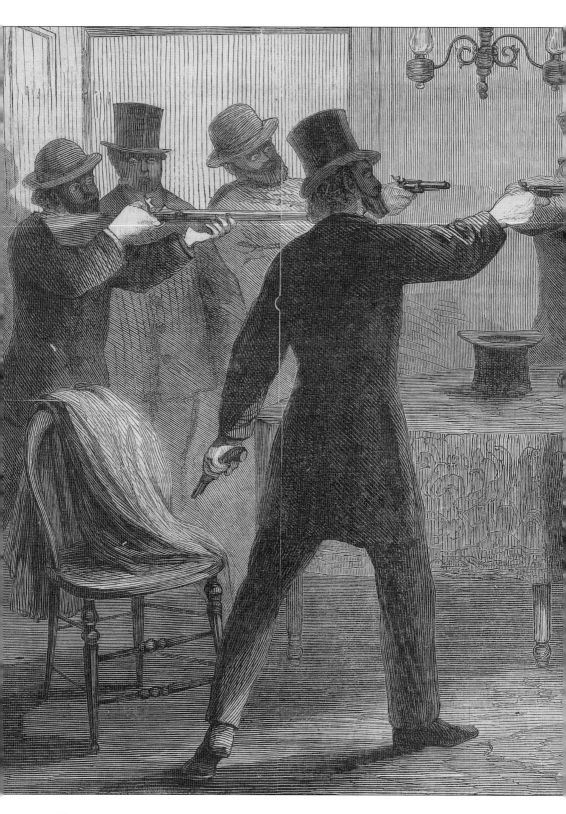

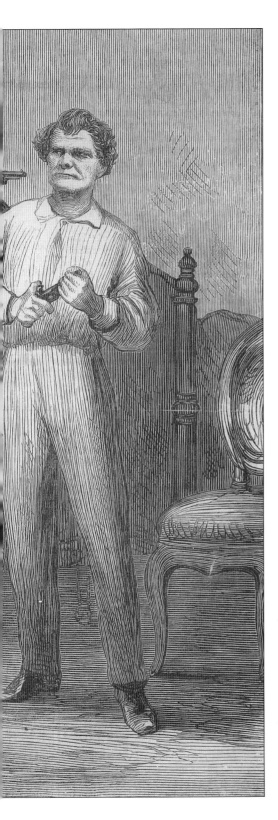

At the close of the Georgia Constitutional Convention of 1868, George W. Ashburn, a leader of the Republican Party and candidate for the US Senate, was murdered by an angry mob of more than 30 Black-faced and paper-masked White men dressed in fine dark suits. Ashburn was killed for encouraging African American delegates to adopt legislation that would protect state legislators from being removed from political office because of their race. He was assassinated on March 31, 1868, and the first person murdered by the Ku Klux Klan in Georgia.

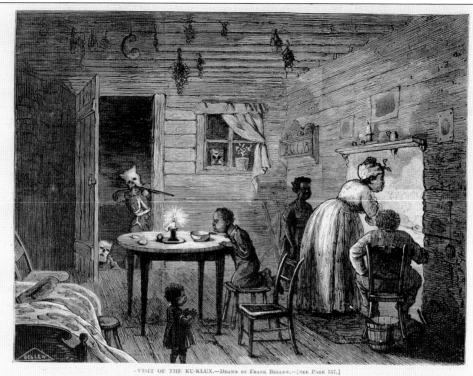

VISIT OF THE KU-KLUX.—Drawn by Frank Bellew.—[See Page 157.]

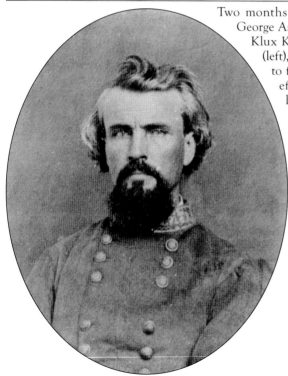

Two months before the assassination of legislator George Ashburn, the first grand wizard of the Ku Klux Klan (KKK), Nathaniel Bedford Forrest (left), campaigned throughout Georgia hoping to find ways to undermine the mobilization efforts of Black and White Republican leaders. Hoping to deter freedmen from voting during the April 1868 election, the terrorist organization committed violent acts against Black families. The murder of Ashburn nor intimidation by the KKK could suppress the Black Republican turnout to the polls.

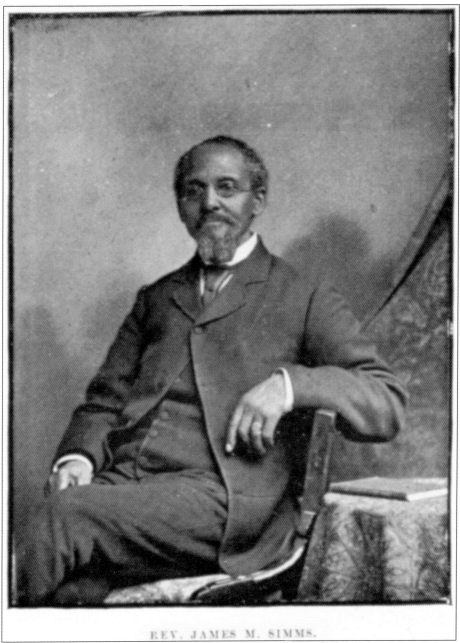

REV. JAMES M. SIMMS.

The first statewide election since the Civil War brought great excitement and tension as Republicans and Democrats mobilized voters to secure seats in the Georgia General Assembly. On April 20, 1868, thirty-three African American men were elected as legislators: 30 state representatives and three state senators. Representatives Henry McNeal Turner, Rev. James M. Simms, and Senators Aaron Alpeoria Bradley and Tunis Campbell Sr. were the most prominent Georgia Black legislators. Rev. James M. Simms of Savannah was self-emancipated in 1857 after purchasing his freedom. During the Civil War, he was appointed as chaplain in the Union army. During his time as minister of the First African Baptist Church in North America, he was elected as a member of the Georgia House of Representatives. (New York Public Library.)

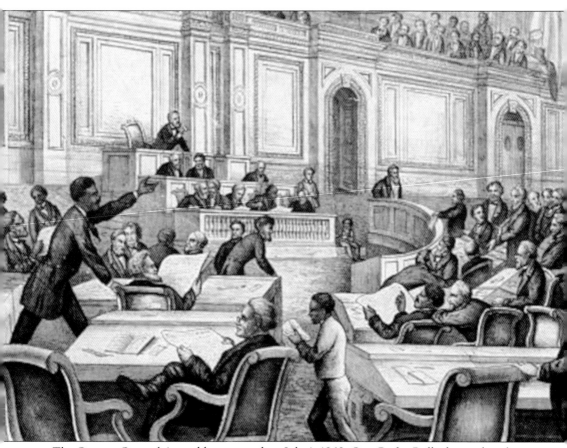

The Georgia General Assembly convened on July 4, 1868. Gov. Rufus Bullock noted to the press that the Democrats have a majority in the lower House, and the Radical Republicans cannot secure a majority unless ousting Democrats by having them removed by Congress. Democrats responded by claiming that African American legislators were ineligible to hold office because of their race. Holding office for less than five months, Democrats and a minority of White Republicans who African Americans assisted in winning seats expelled the 33 Black legislators on September 3, 1868.

> **AARON ALPEORIA BRADLEY.**
> The name of Aaron Alpeoria Bradley, the colored lawyer, has been struck from the roll of attorneys by order of the Chatham County (Ga.) Superior Court, after a trial by jury. He is thereby removed from the practice of law in any of the courts in the State of Georgia, and his license to practice therein is declared null and of no effect. The accusations against him were to the effect that he was convicted in Brooklyn, N. Y., June 13, 1851, of the crime of seduction, and that in October, 1856, he was convicted in Massachusetts of contempt of court and malpractice, and removed from practice in any court in that State, he having collected $70, by virtue of his profession, and failed to pay the same over to his client.

Aaron Alpeoria Bradley was one of the first African American lawyers in the United States. He was a delegate to the Georgia Constitutional Convention and was elected as one of three state senators to the Georgia General Assembly in 1868. The zealous orator advocated for land and labor rights and unabashedly criticized the lower courts, local police, and the prison system for their discriminatory and exploitative actions toward freed people and poor Whites. He amassed a motley band of supporters and was targeted to be removed from office by the White power structure. As a member of the first cohort of African American state legislators, he, too was expelled from office. Pictured are newspaper clippings posted by those who reveled in Bradley's inability to maintain his political seat or his right to practice law in Georgia.

> — Aaron Alpeoria Bradley has been indicted for perjury, in Georgia. And now this distinguished mulatto will be hauled to "the ragged edge."

RECENT DEATHS.

A Noted Colored Clergyman.

Rev. Tunis G. Campbell, who died yesterday morning in Allston, was the oldest clergyman in the African Methodist Episcopal Church. He had been a judge and a military governor, and had lost a fortune in trying to educate his race. He was born in Middlebrook, N. J., April 1, 1812. His father was John Campbell, a blacksmith by trade. At the age of five he was taken in charge by a white man and sent to school at Babylon, L. I. He was the only colored child in the school. Here he remained until he was eighteen years of age. At that time it was desired that he should go to Africa as a missionary. He refused to go, and then he began his career as an anti-slavery lecturer. His father removed to the city of New Brunswick, N. J., in 1832, and it was here that he formed an anti-colonization society, and then pledged himself never to leave this country until every slave was free. While preaching and lecturing he was several times mobbed and once came near being killed. He was the first moral reformer and temperance lecturer that entered the Five Points, in the city of New York. From 1841 until 1846 he was active in establishing schools for colored children in New York, Brooklyn, Williamburg and Jersey City. During the anti-slavery period he helped those slaves who were successful in escaping to the North. The first year of the war he was awarded the contract to raise 4000 colored troops in defence of the Union. In 1863 he sent to President Lincoln a plan whereby the free people of the South could be educated and made self-supporting. No answer came, but in its stead came a commission to report to General Saxton at Hilton Head, S. C. At the fall of Charleston, S. C., he was sent as military governor to the Sea islands of Georgia. Here he organized and established schools and a government, at the head of which he remained for two years. He was afterwards removed by General Tilson. Under the reconstruction act of Congress he was appointed one of the registrars for the second senatorial district of Georgia. Subsequently he was elected a member of the constitutional convention, and then State senator from the same district. From that period until 1874 Mr. Campbell was in constant trouble in the State of Georgia. Owing to political difficulties he and his family were obliged to flee the State to save their lives. On leaving the State he went to Washington, D. C., where he lived for several years. It was about ten years ago that he came to Boston, where he has been chiefly engaged in missionary work for the African Methodist Episcopal Church. His son, Tunis Campbell, Jr., who was with him during those heated times in Georgia, and who has for four years been a representative in the Legislature of that State, survives him. The funeral will take place at the Charles-street Church Sunday, at 12.30 o'clock.

Representing McIntosh County, state senator Tunis Campbell introduced over a dozen bills expanding the rights and freedom of African American Georgians. After he was expelled from office and reseated, he lost his seat in 1872. Countless efforts were made to undermine his credibility. At 63 years old, he was tried and convicted of malfeasance in office and sentenced to one year of hard labor at a convict labor camp in 1876. After his release, he resettled in Washington, DC. There, he lobbied on behalf of African Americans' rights as citizens. He died in Boston on December 4, 1891.

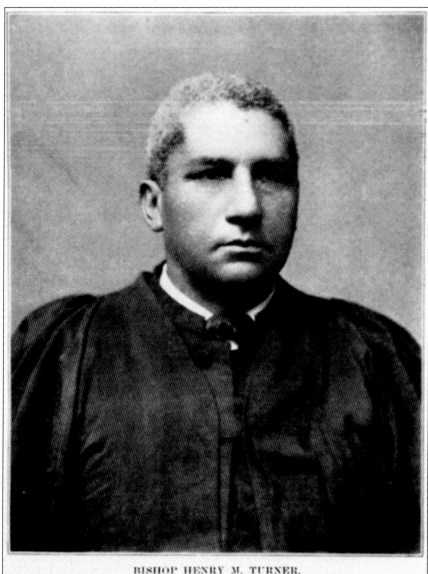

BISHOP HENRY M. TURNER.

Born in Newberry, S. C.—Ordained Bishop in 1880—President of Bishop Council, Home and Foreign Missionary Society and Sunday School Union of the A. M. E. Church—From Slave to Statesman—As Soldier, Editor, Author, Legislator, Orator, and African Explorer—For Vitality and Ability, Courage and Fidelity, Along so Many Lines, He Stands Without a Peer.

Rev. Henry McNeal Turner was recognized as the most powerful and outspoken African American representative of the Georgia General Assembly and organizer of the Republican Party. Democrats and a body of perfidious White Republican legislators declared Turner and the entire body of African American men were incompetent and disqualified to hold office and refused to seat them. Before departing the state capitol, he gave a powerful speech declaring, "I hold that I am a member of this body. Therefore, I shall neither fawn nor cringe nor stoop to beg for my rights." Turner later confessed that he regretted voting against including in the Georgia Constitution the rights of Black men to hold office as advised by his murdered fellow legislator George Ashburn just five months earlier.

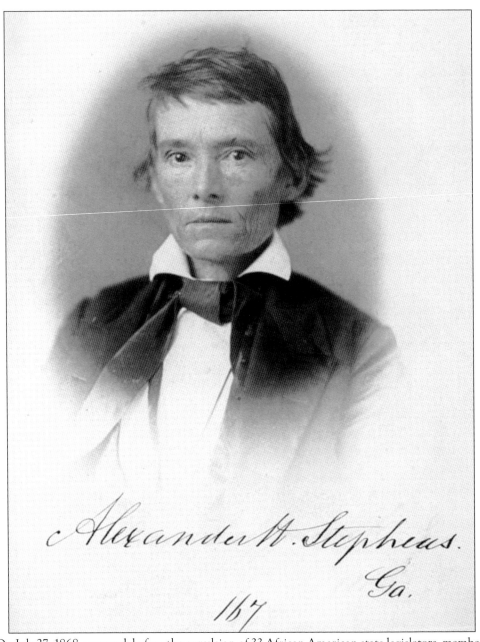

On July 27, 1868, one week before the expulsion of 33 African American state legislators, members of the Georgia General Assembly ratified the 14th Amendment of the US Constitution, granting African Americans full citizenship, due process, and equal protection of the law. Leading up to its passage, Democrats were in opposition to the arrest of the nine men accused of the murder of George Ashburn, a Republican candidate for the US Senate. Jailed in Atlanta, the prisoners' defense teams were future governors, and attorneys Alexander H. Stephens (pictured) and James M. Smith. Ex-governor and recruited Republican Joseph. E. Brown represented the military during the June 29 to July 24, 1868, trial period. Pressured to secure the amendment, a compromise was made by Gen. George Meade to readmit Georgia to the Union. He ended the military trial and released the accused. Meade left Georgia shortly afterward.

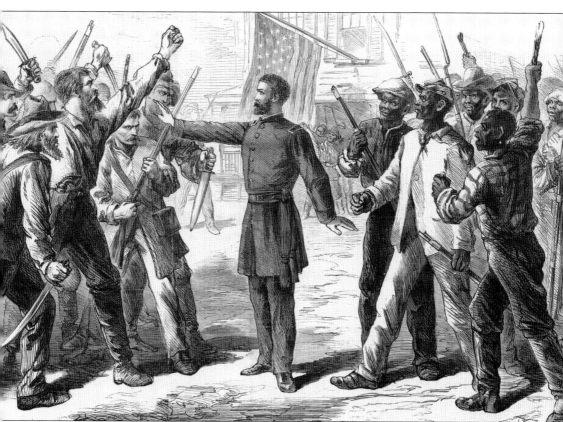

State representative Philip Joiner was barred on September 3, 1868, from holding office alongside 32 other African American legislators. Sixteen days later, Joiner led a 32-mile march from Albany, Georgia, to Camilla, Georgia. The body of 150 to 300 majority Black and White demonstrators were to join other Republicans at a political rally on the Mitchell County courthouse square. Although carrying guns was legal, the sheriff asked the biracial body to surrender their weapons, which they refused. Local Whites, protected by the sheriff, fired on the marchers. Nine to fifteen Black men were killed, and forty others were wounded. The remaining demonstrators retreaded into nearby swamps. This attack became known as the Camilla Massacre. African American voters were beaten, threatened, and told they would be killed if they voted for the remaining weeks leading up to the presidential election.

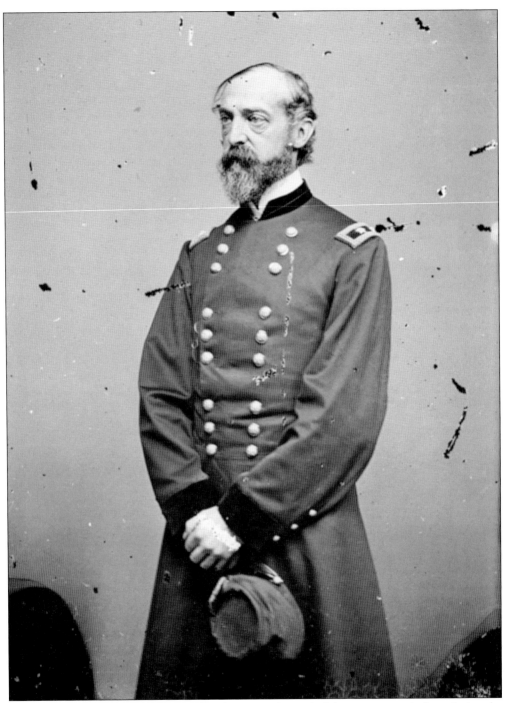

Gen. George Meade (pictured) surrendered carrying the trial of the men accused of murdering the White candidate for US Senate George W. Ashburn, and he failed to continue investigating the Camilla Massacre. Before the ended, Meade abandoned his position as commander of the Third Military District of the US Army that protected African Americans following the Civil War.

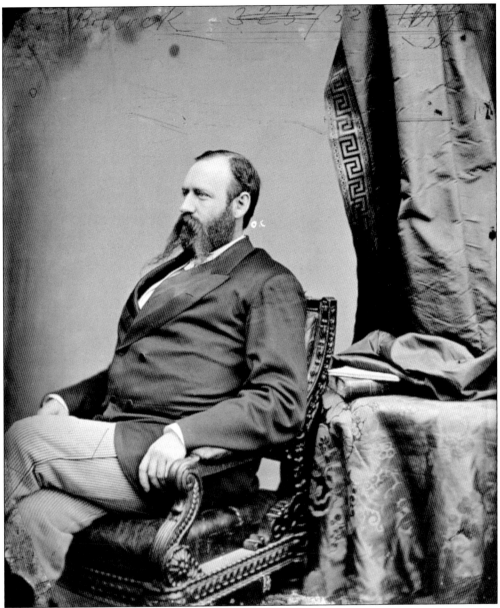

Moving from New York less than five years before the Civil War, Rufus B. Bullock (pictured) became the first Republican elected as governor of Georgia. Although he did not precisely fit the established definition of a "carpetbagger," he was hated by White Southerners for being a northerner, politician, industrialist, and supporter of African American suffrage. The expulsion of African Americans from the Georgia General Assembly in 1868 and the need to protect Black voters during elections resulted in Bullock asking Congress to place Georgia back under military rule by virtue of the Georgia Act in 1869, thereby pressuring legislators to swear their loyalty to the Union. Following the ratification of the 15th Amendment in Georgia, Bullock was threatened by the Ku Klux Klan and forced to flee the state in 1871 to save his life. He resigned as governor on October 30, 1871.

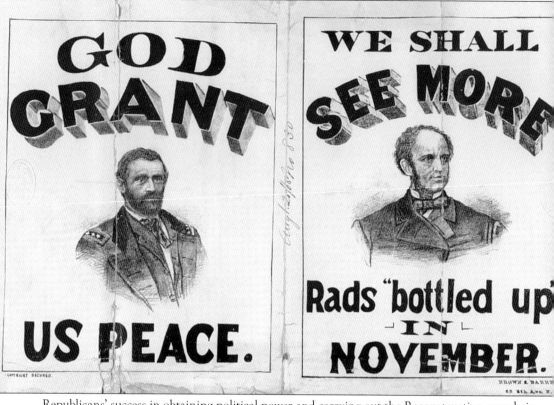

Republicans' success in obtaining political power and carrying out the Reconstruction agenda in Georgia was short-lived, with Democrats quickly obtaining power. Opposing Reconstruction, over 20,000 Democrats gathered during the "Bush Arbor Rally" in Atlanta on July 23, 1868. Enduring hours of oppressive heat, supporters listened to speeches by Robert Toombs and Howell Cobb in support of New York governor and presidential nominee Horatio Seymour. Although he lost to Gen. Ulysses S. Grant, Seymour received 47.3 percent of the popular vote. Above is a campaign poster that played on the names of the Republican and Democrat presidential candidates.

The US presidential election between Republican nominee Gen. Ulysses S. Grant and Democratic nominee Horatio Seymour brought forth a great deal of violence in Georgia and across the South. As freedmen attempted to vote during the first presidential election after the Civil War, the Freedmen's Bureau reported nearly 350 cases of murder and assaults with the intent to kill Black male voters throughout Georgia. However, "carpetbaggers" defined as northern White Republicans and Reconstruction supporters who migrated to the South, also fell victim to threats and violence. Above, Democrats printed a cartoon depicting the fate of northern White transplants if New York governor Horatio Seymour won the presidency. Intimidation from the KKK caused White supporters of African American civil and voting rights to return to the North, retreat, and become silent bystanders. (Alabama Department of Archives and History.)

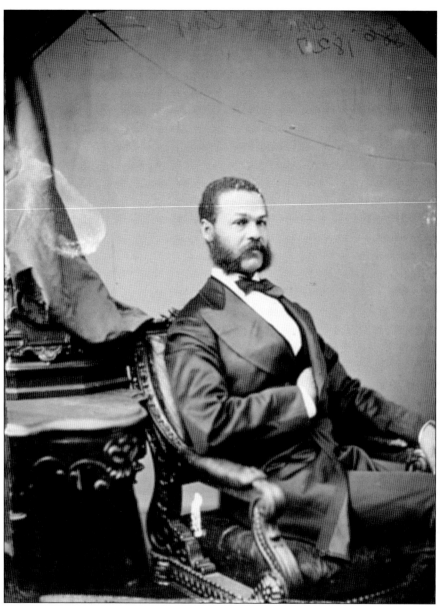

After African American legislators were expelled from the Georgia General Assembly in 1868, Georgia was quickly removed from the Union after being readmitted for ratifying the 14th Amendment. As a precondition of their second readmission, Georgia had to adopt the 15th Amendment, which guaranteed US citizens the right to vote regardless of race, color, or previous condition of servitude. Simultaneously, the Georgia Act placed the state under military rule again on December 22, 1869. The act addressed Gov. Rufus Bullock and African American Republican leaders' appeal for Pres. Ulysses S. Grant and Congress to protect Black male suffrage. Consequently, the expelled Black legislators were reseated in 1870, but one-third were either accused of crimes, jailed, threatened, beaten, forced to flee the state, or killed. During the reelection of 1870, fewer Black men secured state seats. However, Jefferson Franklin Long (above), a tailor from Macon, became Georgia's first African American congressman and was the first Black legislator to speak on the floor of the House of Representatives in Washington, DC. He served for only 46 days in office.

Upon the 15th General Assembly reading and adopting the Georgia General Amendment on February 2, 1870, the southern state was granted a second admission into the Union. As well, the 15th Amendment was ratified and became a part of the US Constitution the following day. (Findagrave.com.)

REV. W. M. FINCH.

In Atlanta, African American voters began mobilizing for the upcoming local election. On December 7, 1870, Rev. William Finch and George Wesley Graham became the first two African Americans elected to serve on the Atlanta City Council. Unfortunately, they were unable to secure reelection the following year. Reverend Finch is pictured above wearing a self-tailored suit, and at left is the funeral notice of Graham, who died in September 1894. (Ancestry.com.)

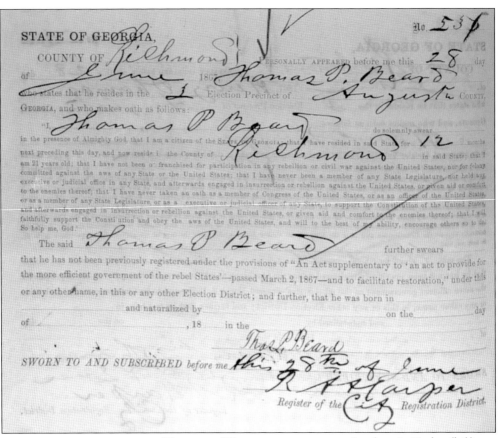

The term of Democrat congressman Stephen A. Corker (left) was equally as short as that of Republican congressman Jefferson Long. Corker was a former slave owner and was the opponent to African American Republican mobilizer Thomas Payce Beard. The Georgia Secretary of State election results presented Corker with 38 percent more votes than Beard, who contested the results claiming Democrats committed voting fraud and exercised violence to force voters to cast their ballot for Corker. Republicans claimed they were shot at, beaten, and mishandled during the election. A federal investigation ensued but the case never went before the Elections Committee. Corker's term was less than 39 days. Pictured are Stephen A Corker and Thomas P. Beard's June 28, 1867, voter registration form. (Above, Ancestry.com; left, Georgia Archives.)

Six years following the Civil War, Democrats regained political power in Georgia. For White Republicans, they became less vocal and faced opposition and intimidation from White Democrats. In response, African Americans began to self-organize and develop strategies to protect their constitutional rights. Recognizing the power of their vote, they pressured Congress to pass the Civil Rights Act of 1875, which ordered that all citizens, regardless of color, shall be entitled to full and equal access to public facilities, hotels, theaters, schools, and restaurants. Denying a person access to such services or accommodations based on race was a crime. Eight years later, the Supreme Court declared the act unconstitutional, leading African Americans to campaign for the next 100 years to secure their rights as full citizens.

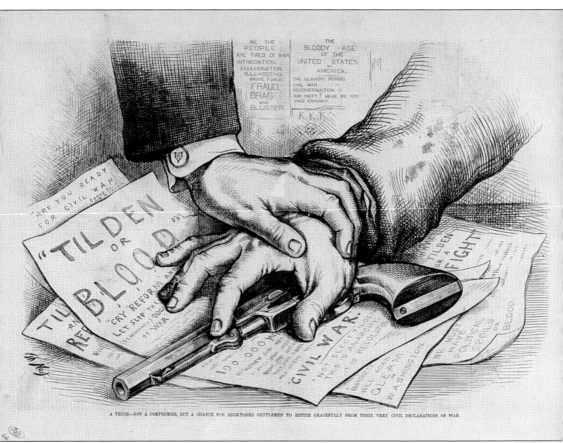

A TRUCE—NOT A COMPROMISE, BUT A CHANCE FOR HIGH-TONED GENTLEMEN TO RETIRE GRACEFULLY FROM THEIR VERY CIVIL DECLARATIONS OF WAR.

After widespread violence and allegations of election fraud, Reconstruction ended with the "Compromise of 1877," a negotiation between political parties to declare the winner for the highly contested US presidential election of 1876. Republican nominee Rutherford B. Haynes secured the presidency and agreed to support the Democratic Party's order to remove federal troops from the South if the Democratic nominee Samuel Tilden conceded. Democrats regained political power and in 1877, Georgia became the first state to impose a "poll tax," which disenfranchised both poor Black and White male voters. Confederate governor and converted Republican Joseph Brown returned to the Democratic Party and served as US senator for 10 years. He joined Alfred H. Colquitt and John Brown Gordon to form the Bourbon Triumvirate. Working cojointly and at odds with each other, this trio held the highest offices in Georgia and controlled the state politically until 1894.

Three

THE SECOND WAVE
BIRTH OF JIM CROW, BIRTH OF A NATION, 1895–1948

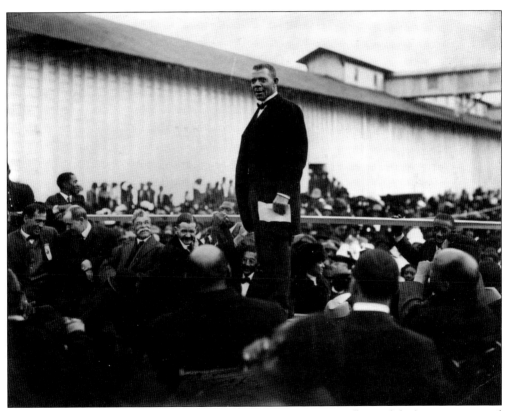

In 1895, Booker T. Washington delivered his "Atlanta Compromise" speech before an integrated audience in Piedmont Park during the Cotton States Exposition. There, he espoused racial separatism and asked Blacks to prioritize economic autonomy and to seek suffrage rights later. While Whites applauded his political stance, he left Blacks stunned. Consequently, Washington's speech ignited the second wave of the long civil rights movement as Blacks began organizing to secure voting rights.

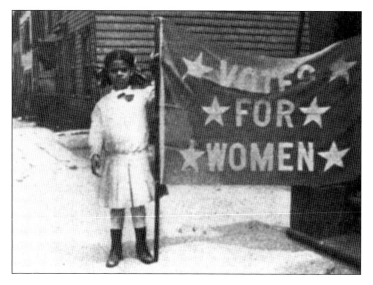

As the suffrage movement gained momentum, the National American Woman Suffrage Association (NAWSA). looked to Atlanta to host its first convention in the American South. Held in 1895, the programs, speakers, and parades were segregated along racial lines. One year later, Black suffragists formed the National Association for Colored Women (NACW). (The Crisis magazine.)

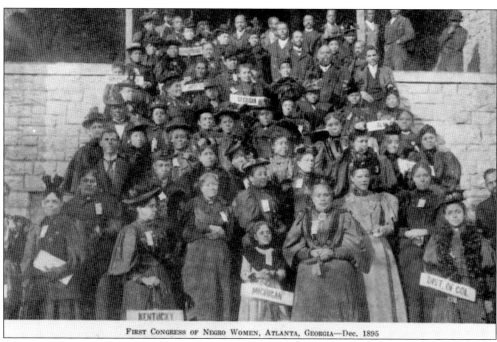

The National Council of Negro Women met in Atlanta during the Cotton State Exposition in 1895. They organized to demand the vote and to address racial violence and discrimination. Above, delegates of the First Congress of Negro Women are photographed before Big Bethel AME Church on Auburn Avenue. (New York Public Library.)

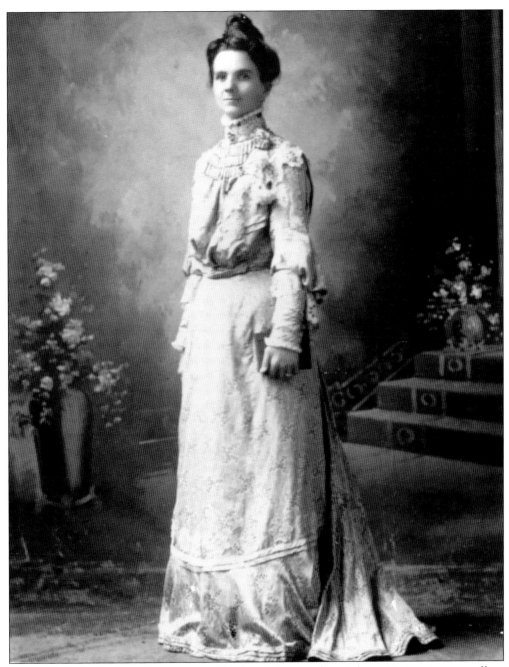

Adella Hunt Logan became a young suffragist while attending Atlanta University as a college student. In 1896, Logan joined the National Association of Colored Women and chaired the suffrage department for many years as she worked alongside other Black Georgia suffragists: Adrienne Herndon, Lucy Craft Laney, and Lugenia Burns Hope. Additionally, Logan spoke out against the horrors of lynching and racial segregation. By 1901, she was the only African American woman to obtain a lifetime membership with the National American Woman Suffrage Association led by White suffragists.

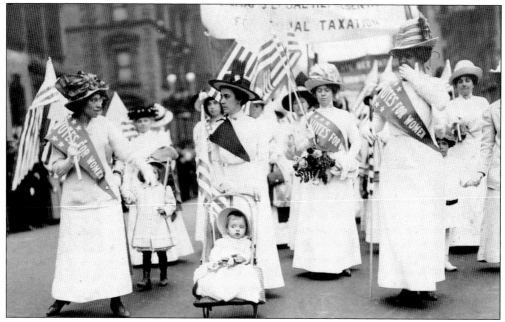

Helen Augusta Howard of Columbus, Georgia, founded the Georgia Women Suffrage Association (GWSA), a branch of the NAWSA. By 1893, Howard established chapters in five counties throughout the state. She is credited with influencing Susan B. Anthony and Elizabeth Cady Stanton to hold its NASWA convention in Atlanta, Georgia where more than 2,000 participants attended from January 31 to February 5, 1895. (Findagrave.com.)

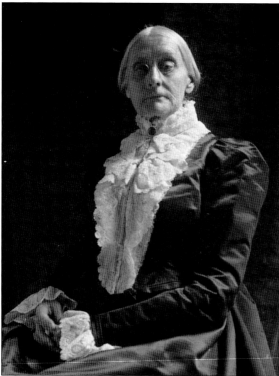

During the 1895 NAWSA convention in Atlanta, Georgia, suffragist Susan B. Anthony presented at the Grand Opera House. Although she spoke before an integrated audience at Atlanta University, she failed to respect the leadership and organizational efforts of Black suffragists.

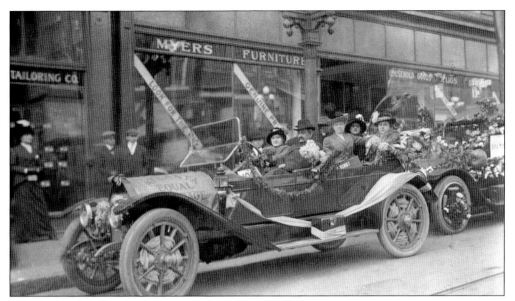

Atlanta Equal Suffrage members participated in a 1913 parade in Atlanta, Georgia. Pictured from left to right are Mamie Matthews, Eli A. Matthews, Amelia R. Woodall, Margaret Kock, and Kate Koch. (Kenan Research Center, Atlanta History Center.)

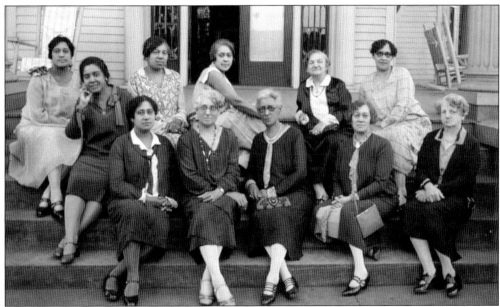

Lugenia Burns Hope (first row, second from right) was a leading suffragist and social reformer. She was an early member of the National Council of Colored Women. As the first woman to serve as vice president of the Atlanta branch of the NAACP, she created and oversaw "citizenship schools." Hope is pictured with Atlanta suffragists and supporters of the Neighborhood Union she founded in 1908. (Robert W. Woodruff Library Archives, Atlanta University Center.)

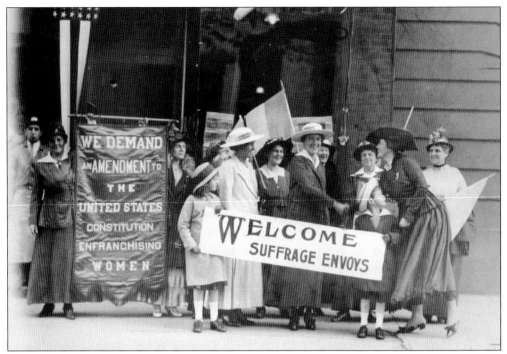

In 1919, Congress voted in favor of the 19th Amendment, granting women the right to vote. However, Georgia was the first state to oppose the Amendment. In 1920, Congress ratified the amendment with the support of 38 other states. Women across the nation voted while women in Georgia remained disenfranchised. They could not cast a ballot during national elections until 1922. Although women voted afterward, Georgia did not ratify the 19th Amendment until 1970.

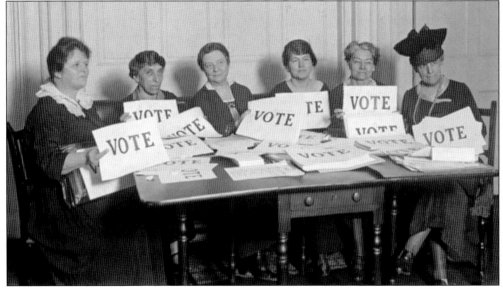

In 1920, over 20 suffrage activists from various organizations formed the League of Women Voters of Georgia. The league was established in the home of Emily C. McDougald, a leading Atlanta suffragist and former president of the Equal Suffrage Party of Georgia. League women are pictured displaying the word "VOTE."

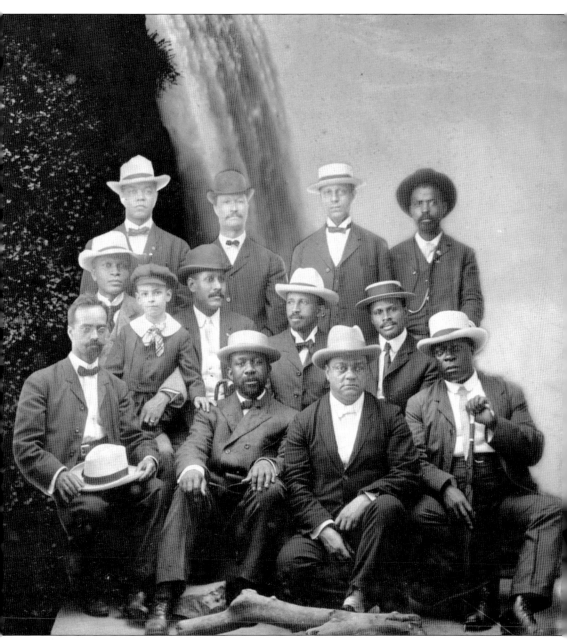

In 1905, over 60 African American men formed the Niagara Movement. They rejected Booker T. Washington's principles favoring racial separatism and gradualism. This body of businessmen, academics, journalists, and civic leaders demanded full citizenship, the right to vote and own land, access to public health and housing, and passage of legislation to end racial segregation, discrimination, and violence. The organization was established in Ontario near Niagara Falls but its formative meetings were held in Atlanta and led by Atlanta University professor W.E.B. Du Bois (second row, second from right). Additional Atlantans pictured are Norris Herndon (young boy), journalist Max Barber (second row, third from left), and millionaire Alonzo Herndon (third row, second from left). The Niagara Movement was the forerunner to the NAACP.

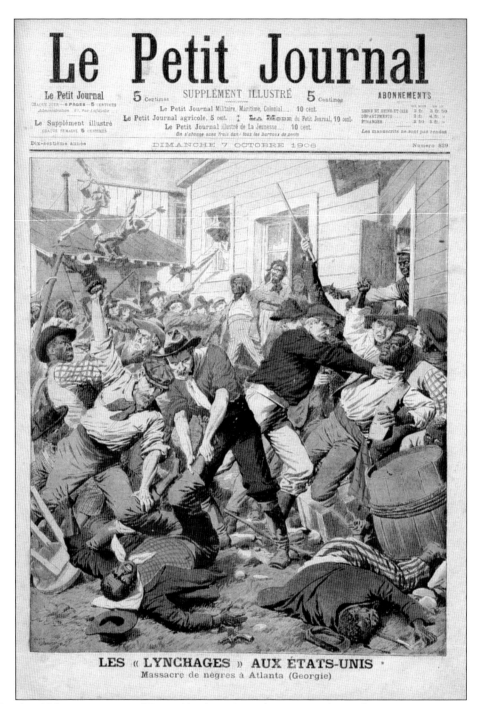

On the 44th anniversary of Pres. Abraham Lincoln signing the Preliminary Emancipation Proclamation, racial violence exploded in Atlanta, Georgia, on September 22, 1906. The *Atlanta Constitution* and *Atlanta Journal* newspapers incited a three-day city-wide race riot by employing fear tactics during the gubernatorial election. Some newspapers reported the deaths of two Whites and dozens of African Americans. The death toll remains uncertain. (Kenan Research Center, Atlanta History Center.)

Owner of the Atlanta *Constitution* Clark Howell (right) and former owner of the *Atlanta Journal* Hoke Smith (below) competed to win the Democratic nomination for governor in 1906. Both candidates and newspapers encouraged the printing of erroneous stories of Black men sexually assaulting White women and claimed to be the most ardent supporters of White supremacy and disfranchising Black male voters. Hoke Smith won the Democratic nomination and became governor of Georgia. He served from 1907 to 1909.

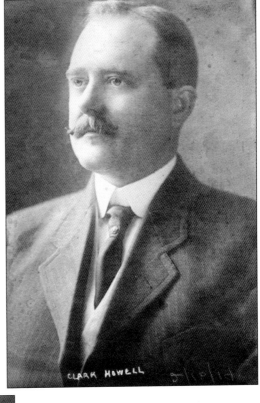

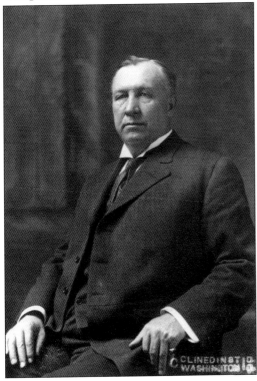

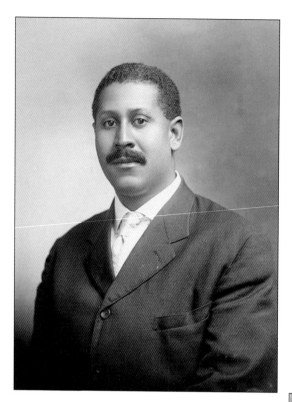

Jesse Max Barber was the editor-in-chief of the *Voice of the Negro* in Atlanta. By 1906, the *Voice* was the leading African American magazine in the United States. After the Atlanta Race Riot, he faced threats from White vigilantes and was forced to flee the city. He was also intimidated by Booker T. Washington and ultimately gave up his profession as a journalist. Barber resettled in Philadelphia to become a dentist.

Representing McIntosh County, W.H. Rogers was the only African American member of the Georgia General Assembly from 1902 to 1907. He resigned after a bill to disenfranchise Black male voters passed in the Georgia legislature signed by Gov. Hoke Smith. The bill was introduced just a few weeks removed from the anniversary of the 1906 Atlanta Race Riot. (Newspapers.com.)

NEGRO LEGISLATOR SENDS RESIGNATION

Special to The Macon News.

Atlanta, Ga., Sept. 11.—The resignation of W. H. Rogers, of McIntosh county, the only negro member of the legislature, was received yesterday at Governor Smith's ofifce during his absence in Sparta.

The resignation will undoubtedly be accepted.

Rogers assigns no reason for his resignation, but it is attributed to the passage of the negro disfranchisement law by the last legislature. That measure was one of the few questions which he was heard to speak on during the last session, the other being in opposition to a bill prohibiting the use of a drag net and a bull net in catching shad in the waters of Georgia. His seat in the last legislature was contested by a white man, but he was seated upo nthe unanimous recommendation of the house committee on privileges and elections.

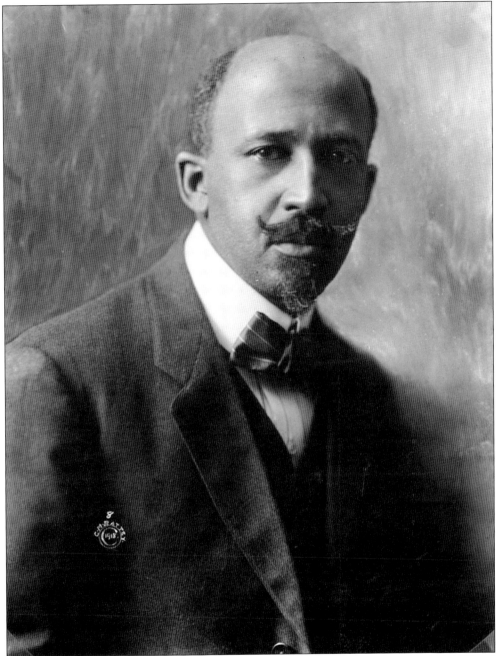

Atlanta University professor and activist W.E.B. Du Bois became a cofounder of the NAACP and relocated to New York City in 1910 to serve as the editor of the *Crisis* magazine. Du Bois criticized Booker T. Washington's acceptance of racial separatism and segregation, which he argued allowed Whites to deny African Americans the right to vote.

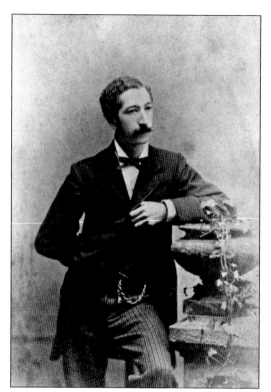

In Atlanta, the Jewish population grew from 600 in 1860 to 4,000 in 1910. Their upward trajectory became a point of concern for power-seeking Whites as Jews began to acquire political office, wealth, and social status. Although small in representation, they were elected to political office and contributed greatly to improving Atlanta's commercial, educational, public health, and overall well-being. (William Breman Jewish Heritage Museum, Ida Pearle and Joseph Cuba Community Archives for Southern Jewish History.)

By 1913, a campaign was formed against those of the Jewish faith to suppress their political and socioeconomic success in Atlanta and across the nation. Aaron Haas (above) became mayor pro tempore of Atlanta in 1875, and David Mayer (right) became a founding member of the Atlanta School Board in 1872. (William Breman Jewish Heritage Museum, Ida Pearle and Joseph Cuba Community Archives for Southern Jewish History.)

In 1908, B'nai B'rith, the oldest and world's largest Jewish service organization, began contemplating ways to respond to rising attacks on Jews throughout the United States. During a convention held in Michigan, the Anti-Defamation League was established on July 10, 1913. Its first organization meeting was not held until October 1913. (ADL.org.)

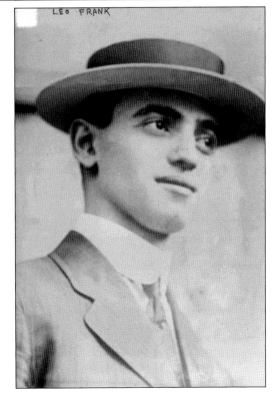

In 1912, Leo Frank, superintendent of the Atlanta National Pencil Factory and Cornell University graduate, was elected president of the Atlanta chapter of B'nai B'rith.

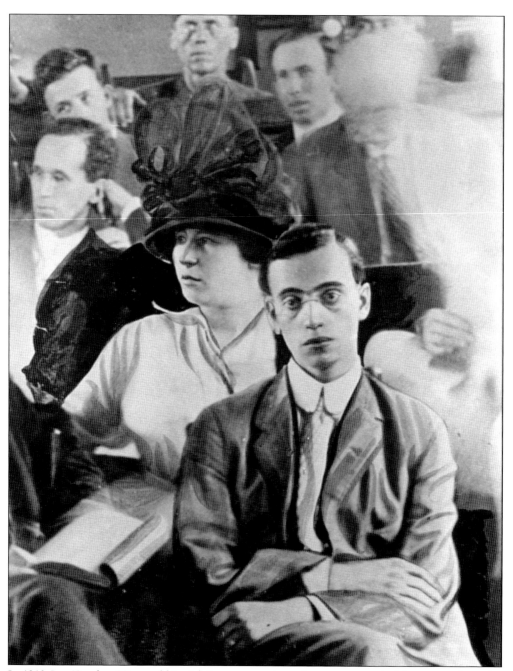

In 1913, Leo Frank, a 29-year-old Jewish factory superintendent was accused of the rape and murder of Mary Phagon, a White 13-year-old child-employee. Her body was found in the Atlanta National Pencil Factory cellar on April 26, 1913, the 48th anniversary of John Wilkes Booth's death, also recognized as "Confederate Memorial Day." The factory janitor claimed he and Frank moved Phagan's body. Captured in a daze of disbelief, Frank is photographed sitting before his wife, Lucille, in the courtroom. The trial became highly sensationalized and politicized by conservative newspapers and elected officials. (Associated Press.)

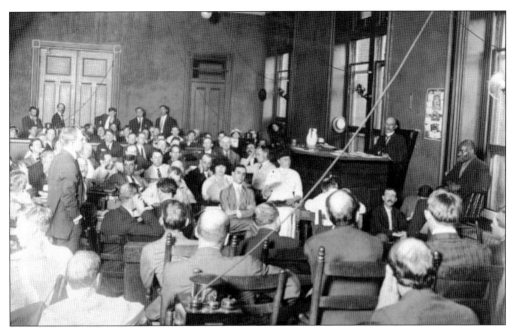

The trial of Leo Frank began on July 25, 1913. Despite weak evidence and false and incoherent testimonies, the jury returned with a guilty verdict. On August 25, 1913, Frank was sentenced to die by hanging. (Alamy.)

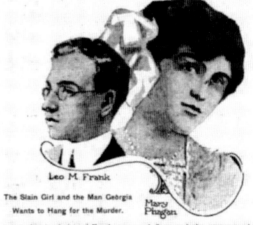

Pictured, a journalist reported on numerous witnesses who recanted their original testimonies against Leo Frank and how evidence in the case was faulty.

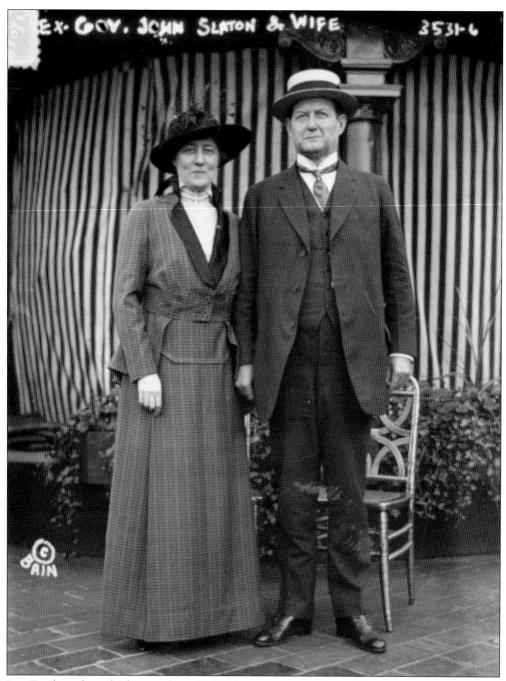

Leo Frank made multiple appeals to the US Supreme Court for nearly two years but was denied. Gov. John Marshall Slaton took an interest in the case and viewed over 10,000 documents. Instead of Frank being punished to die by hanging, Gov. Slaton commuted the death sentence to life in prison. Days later, an angry mob arrived at Buckhead's subdivision where the governor lived. He and his family were escorted by the Georgia National Guard police to board a train. Governor Slaton and his wife, Sarah "Sally" Frances Grant, did not return to Georgia until a decade later. Here, the couple was photographed six weeks before being forced to flee Atlanta.

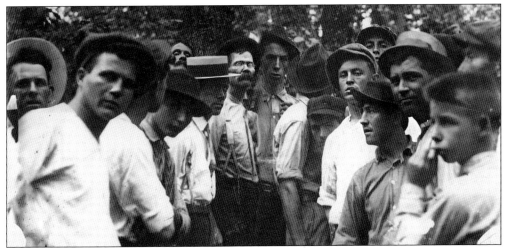

After Gov. John Marshall changed Leo Frank's sentence to life imprisonment, a mob of 25 masked men, mostly legislators and judges, calling themselves the "Knights of Mary Phagan," stormed the state prison in Milledgeville and kidnapped Frank from his cell in the dark of the night. The mob's ringleader was former Georgia governor Joseph Mackey Brown (right). On August 17, 1915, Frank's body was found hanging from a tree on a city street near the graveyard where Mary Phagan was buried in Marietta, Georgia. Thousands of men arrived to see the corpse (above). A detective, local judge, and undertaker retrieved the body and placed it in a car to save it from mutilation. The mob chased them by automobile, buggy, and foot as the trio raced to return the body to Frank's family in Atlanta. (Above, Georgia Archives.)

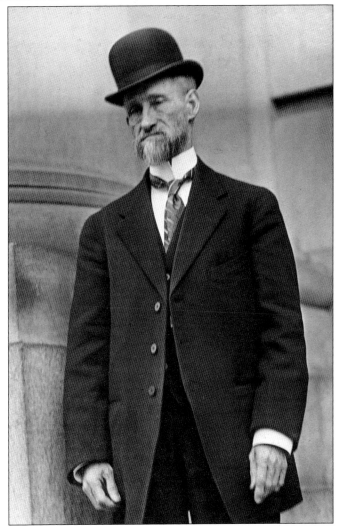

The Philadelphia *Evening Ledger* offered descriptive details of the kidnapping and lynching of Leo Frank by a White mob in Marietta, Georgia. After Frank's murder, Jewish residents in Atlanta left the city or remained and went into isolation. They did not seek political office again until the Civil Rights Act of 1964 and the Voting Rights Act of 1965 passed.

Jim Conley, the factory janitor and testifier against Leo Frank, was found guilty as an accessory in the murder of Mary Phagan and received a one-year sentence of hard labor. In 1982, Alonzo Mann, a 14-year-old factory worker at the time of the trial, named Conley as the murderer. (*Watson's Magazine*.)

Tom Watson, a politician and editor of the *Jeffersonian*, shaped prejudiced attitudes toward Blacks, Jews, and Catholics in Georgia. Anti-Semitism heightened during the trial as Watson presented Frank as miserly and Phagan as the daughter of poor White tenant farmers. Watson also provoked protesters and encouraged them to demonstrate their opposition toward Governor Slaton's decision to commute Frank's sentence.

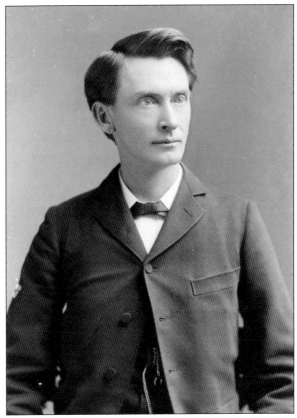

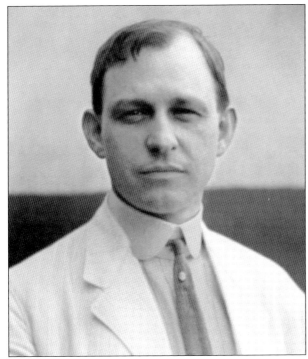

Hugh Dorsey, solicitor-general of the Atlanta Judicial Circuit, became famous in the prosecution of Leo Frank. Dorsey ran for governor in 1916 and won the election with the support of Tom Watson. Dorsey held the position from 1917 to 1921. He ran for the US Senate but lost to Watson. Afterward, he documented 135 cases of lynching and other violent acts against Black Georgians. (Findagrave.com.)

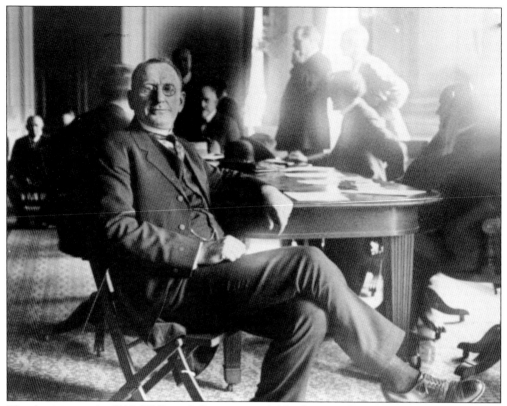

Thanksgiving night 1915, William J. Simmons and 16 other Knights of Mary Phagan members gathered at the top of Stone Mountain in Stone Mountain, Georgia. They ignited a flaming cross and declared the rebirth of the Knights of the Ku Klux Klan. Simmons designed the White hooded robe, composed an arduous ritual for the secret order, and secured an official charter from Georgia. (Above, Britannica.com.)

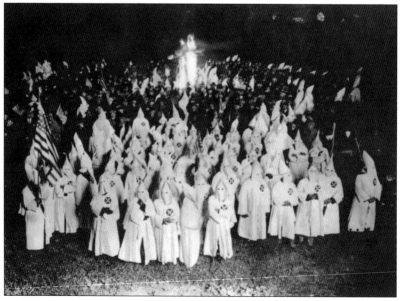

On December 6, 1915, the 50th anniversary of the ratification of the 13th Amendment, D.W. Griffith's blatantly racist film, *Birth of Nation* was screened at the Atlanta Theater, formerly located at 23 Exchange Place. At the movie's completion, Klan members marched down Peachtree Street. The movie attracted the attention of thousands of moviegoers nationwide and was even presented at the White House and viewed by Pres. Woodrow Wilson. In 1921, when William J. Simmons was asked by the US House of Representatives his reason for resurrecting the KKK, he unabashedly stated he was motivated by the trial of Leo Frank and the film *The Birth of a Nation*.

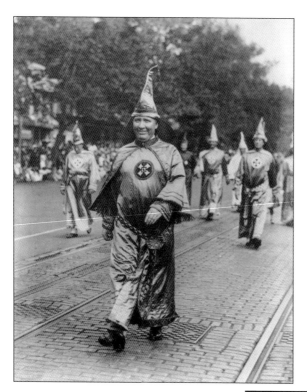

In 1922, Hiram W. Evans (pictured) of Atlanta became the Imperial Wizard of the KKK. He pushed to make the Klan a powerful political machine and recruited nearly six million members nationwide by 1925, including local, state, and federal legislators.

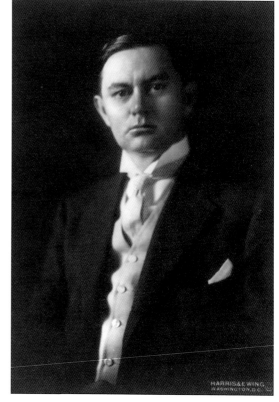

During the gubernatorial election, Gov. Thomas Hardwick spoke out against the KKK during his reelection campaign, but he could not amass enough support to defeat Clifford Walker, who was associated with the Klan.

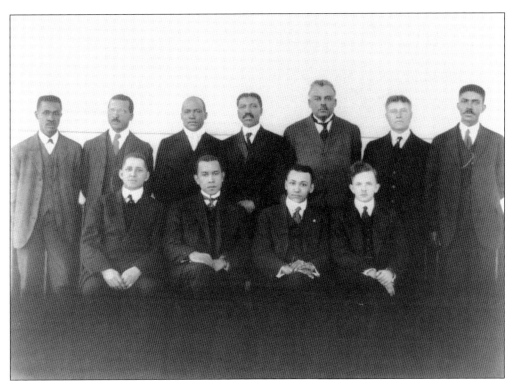

The Atlanta branch of the NAACP was established in 1917 to secure the protection of voter rights for African Americans. Pictured from left to right are (first row) Harry H. Pace, Dr. Charles H. Johnson, Dr. Louis T. Wright, and Walter F. White; (second row) Peyton A. Allen, George A. Towns, Benjamin J. Davis Sr., Rev. L.H. King, Dr. William F. Penn, John Hope, and David H. Sims.

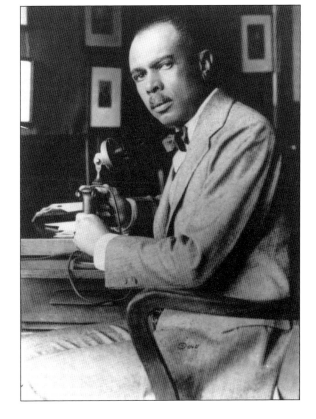

James Weldon Johnson, an Atlanta University graduate, became the first African American executive secretary of the NAACP in 1920. Beyond being the lyricist and composer of the Black national anthem "Lift Every Voice and Sing," he fought tirelessly against lynching, racial segregation, voting discrimination, and other Jim Crow practices.

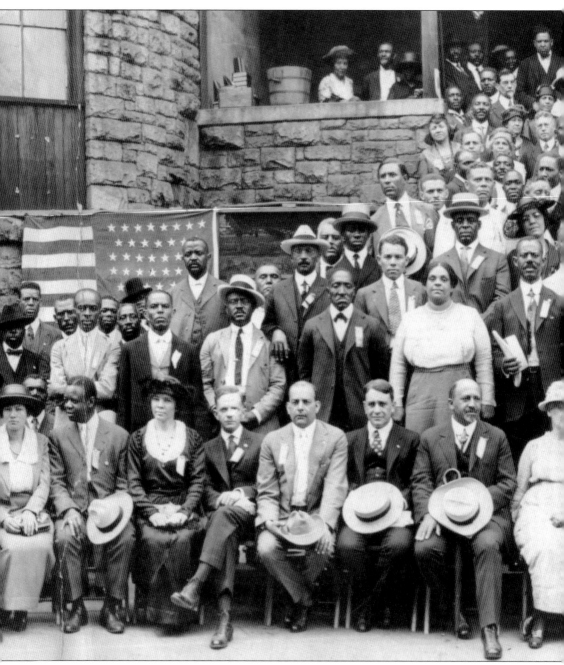

The NAACP held its national convention in Atlanta, Georgia, on June 1, 1920. Photographed on the steps of Big Bethel African Methodist Episcopal Church are NAACP members, cofounders,

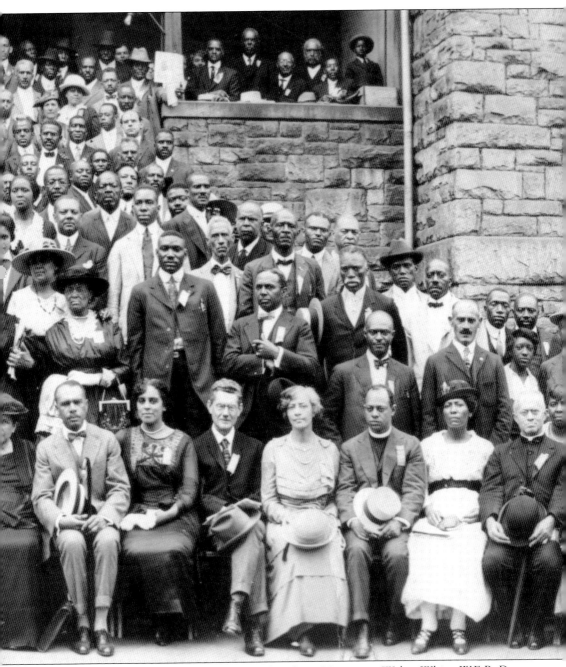

and executives. Sitting are leaders associated with Atlanta University, Walter White, W.E.B. Du Bois, and James Weldon Johnson.

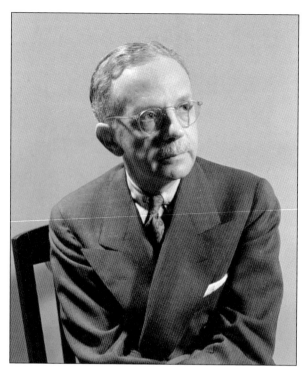

Walter White of Atlanta became the second Black Executive Secretary of the NAACP in 1931. Unbeknownst to Whites, he was African American. He infiltrated the KKK and investigated the lynching of Blacks. For 25 years, he worked to convince Congress to pass an anti-lynching bill. In 1930, he almost singlehandedly won the US Senate's support to reject Judge John J. Parker's appointment to the US Supreme Court for opposing Black suffrage.

Atlanta University professor George A. Towns worked against voting discrimination throughout his life. He was a founding member of the Niagara Movement in 1905 and the first president of the Atlanta branch of the NAACP. In 1946, he ignited a voting rights campaign. His daughter, Grace Towns Hamilton, and other Black civic leaders and organizations joined him. More than 21,000 Black Atlantans were registered.

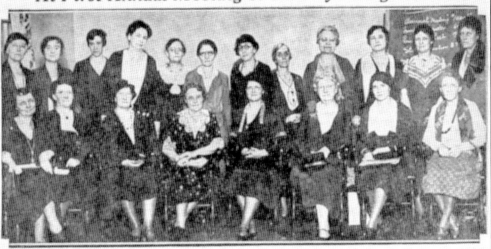

The lynching of African Americans increased during election periods and was used as a fear tactic to mobilize White voters and disenfranchise Black voters. The Association of Southern Women for the Prevention of Lynching, an all-White women's organization, formed in 1930 to campaign against mob violence in Georgia and 12 additional states across the South. (Newspapers.com)

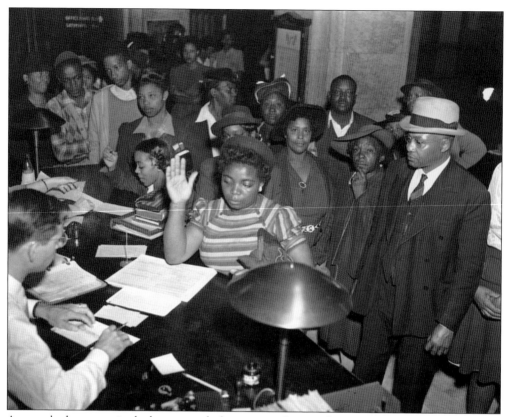

A watershed moment in the long struggle for voting rights was the US Supreme Court decision in *Smith v. Allwright*, declaring it unconstitutional to deny a citizen, regardless of race, from participating in primary elections, often referred to as "White primaries." In response to the *Smith* decision, thousands of African Americans appeared at the Fulton County courthouse in Atlanta, Georgia to register to vote for the 1944 Georgia Democratic primary.

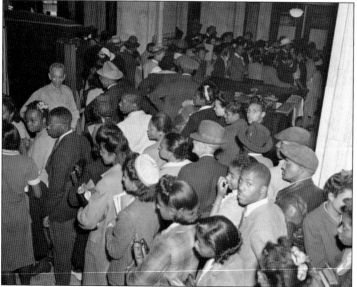

Fulton County clerks in Atlanta estimated 5,000 Blacks and 6,000 Whites registered to vote between May 3 and May 5, 1944. While registration efforts were successful, Blacks were denied the opportunity to vote during the succeeding Democratic primary. Poll officials claimed the names of Black voters were not on the registration list.

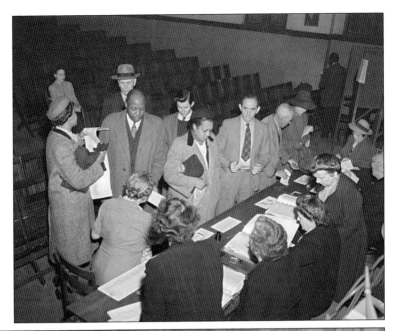

Despite being denied the right to vote in the July 4, 1944, Democratic White primary election, African Americans did participate in the November 7 general election. Here, Black and White voters are photographed at a fifth-ward precinct located at the Forrest Avenue School in Atlanta, Georgia.

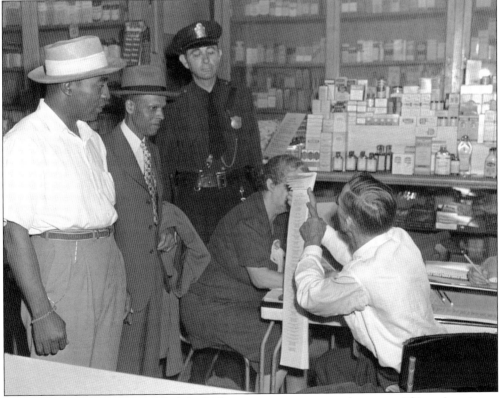

In 1945, Georgia's poll tax was abolished. Voter registration increased amongst African Americans, but their effort to successfully participate in the Democratic primary election was met with opposition from White poll officials. Pictured are Lewis K. McGuire, a World War II veteran (left), and S.M. Lewis, a physician (right), who attempted to vote on September 5, 1945.

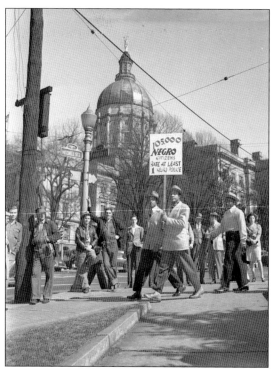

As the number of registered Black voters increased in Atlanta, racial intimidation from White terror groups and police officers ensued. In March 1946, the United Negro Veterans and Women's Auxiliary organized 200 demonstrators to march against police brutality and demand the hiring of Black police officers. World War II veterans and supporters carried placards bearing the words, "105,000 Negro Citizens Rate at Least 1 Negro Police." Before assembling on the steps of the Atlanta City Hall, protesters circled the building twice shouting, "Square Deal for the Negro." White city officials and police officers stood at the periphery of the crowd as Black demonstrators listened to speakers.

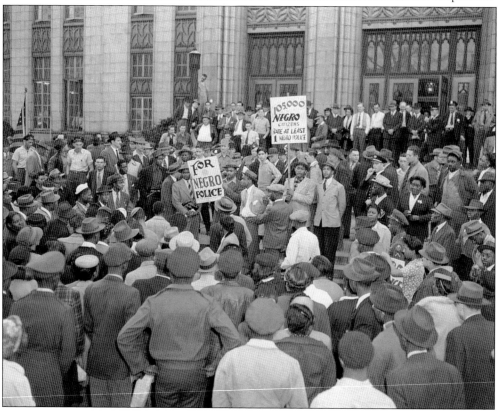

Across Georgia, African Americans attempted to participate in the 1944 "White primary" election. After being denied the right to vote Primus King of Columbus, Georgia filed suit. In 1946, the famous US Supreme Court decision in *King v. Chapman* declared it was unconstitutional to prevent African Americans from voting in any election. (Columbus State University.)

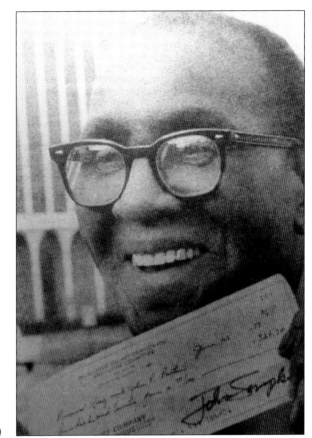

Thomas Brewer, a physician, local NAACP leader, and voting rights activist, raised the funds for the legal representation of Primus King. Brewer was successful in initiating several voter registration campaigns over the next decade. He was killed in 1956. (Columbus State University.)

79

In 1946, African Americans throughout Georgia registered to vote in massive numbers, producing its greatest voter turnout since Reconstruction. In Atlanta, the Black electorate expanded from less than 7,000 to more than 21,000. (Associated Press.)

The 1946 voter registration campaign in Atlanta was organized through the concerted efforts of civic and community leaders: A.T. Walden, attorney and cofounder of the Fulton County Citizens Democratic (FCCD) Club (above), and John Wesley Dobbs, grandmaster of the Prince Hall Masons of Georgia and founder of the Atlanta Civic and Political League (right). (Associated Press.)

The efforts of women to organize voters during the 1946 registration campaign cannot be ignored. Pictured is Grace Towns Hamilton, executive director of the Atlanta Urban League. Twenty years later, she became the first African American woman elected to the Georgia General Assembly and served from 1966 to 1985.

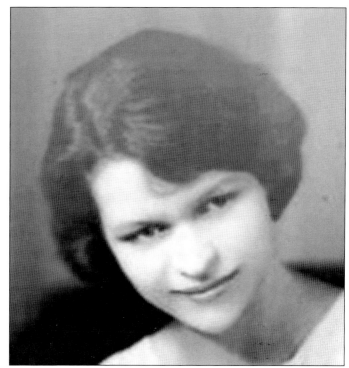

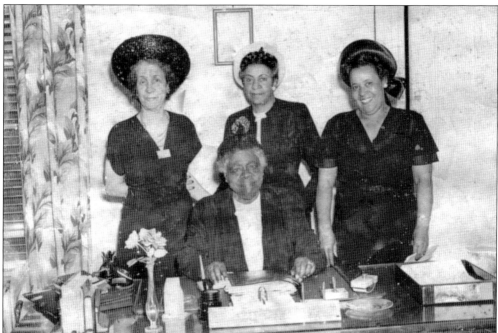

One of the greatest grassroots leaders and mobilizers of the Black female vote was Ruby Parks Blackburn, a beautician and organizer of the To Improve Committee Club, the Atlanta Cultural League and Training Center, and the Negro League of Women Voters. Blackburn is pictured (far right) with National Council of Negro Women founder and president Mary McLeod Bethune (seated). (Auburn Avenue Research Library.)

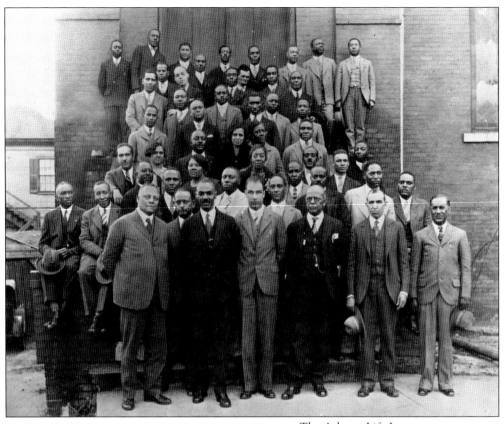

The Atlanta Life Insurance Company supported the campaign for suffrage rights throughout the civil rights movement. The Atlanta Life Insurance Company's president Norris Herndon (first row, center) and employees are pictured. (Auburn Avenue Research Library).

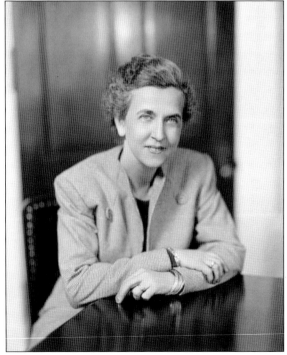

Helen Douglas Mankin's first tenure as a state representative was in 1936. However, in 1946, she was elected as a member of Congress during the Democratic primary election by a majority Black voting precinct in Atlanta. Being the first Georgia woman elected a member of Congress, she was quickly removed from office by an all-White male legislative body.

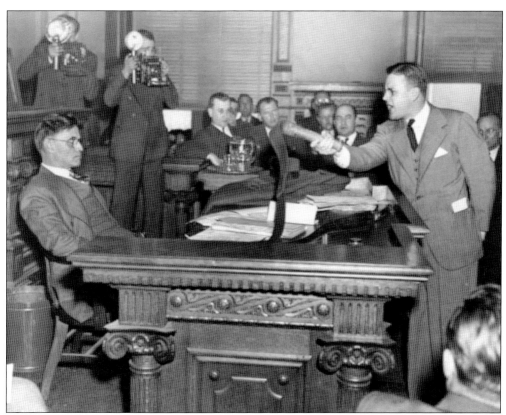

Conservative Democrats returned to fear tactics, violence, and dissension employed since the Civil War to try to sustain political power in Georgia. History has failed to tell the narrative of how White supremacy was challenged by progressive Whites. Assistant District Attorney Dan Duke (standing) prosecuted several members of the Klan for flogging and murdering a 37-year-old White barber, Isaac William Carter Gaston (erroneously identified as Black by newspapers), in 1940. Pictured below is the gravesite of Gaston located in East Point, Georgia. According to Duke, the Klan used flogging to intimidate Blacks and to control poor and rural Whites. During a clemency hearing for six Klansmen, Duke is pictured confronting Gov. Eugene Talmage (sitting) with two whips left near the frozen body of Gaston. (Below, Findagrave.com.)

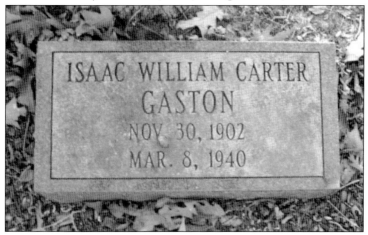

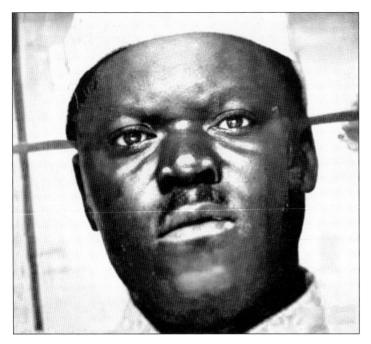

The Georgia elections of 1946 brought forth violence throughout the state after World War II as African Americans, Jews, Catholics, and progressive Whites fought to end discriminatory voting policies. After American soldiers returned from the war, some Black veterans faced brutal attacks and were murdered for casting a ballot. Veteran Maceo Snipes of Rupert, Georgia, was fatally shot for voting during the Democratic primary election on July 18, 1946. (Raynita S. Johnson.)

Pictured is the signed draft card of Maceo Snipes. He enlisted in the Army in 1943 and served for 18 months before returning to Georgia in 1944. Snipes was the only African American to cast a ballot at the Taylor County voting precinct during the primary election of 1946. He was confronted, shot, and killed. Two of his murderers were identified as World War II veterans Edward Williamson and Lynwood Harvey. (Ancestry.com.)

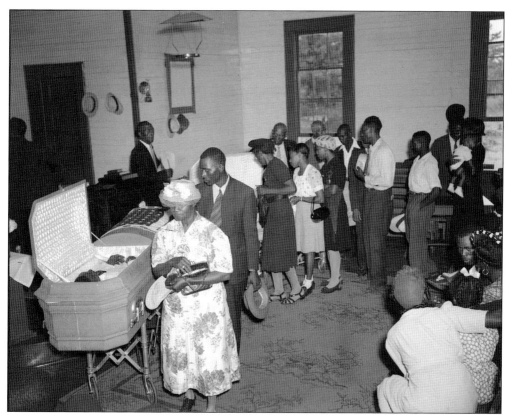

Atlanta was profoundly impacted by racial tension from surrounding cities. On July 26, 1946, the city rose to the news of a mass lynching in Walton County, 45 miles beyond the Atlanta city limit. The *Atlanta Daily World*, *Atlanta Constitution*, and *Atlanta Journal* identified the four victims executed on a dirt road near Moore's Ford bridge as World War II veteran George Dorsey, Mae Murray Dorsey, Dorothy Malcom, and Roger Malcom.

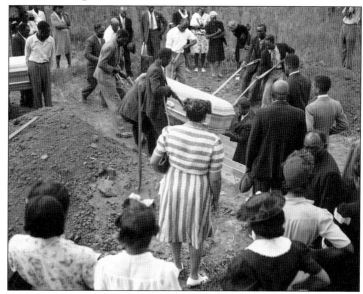

Atlanta newspapers did not shy away from bringing attention to the quadruple murder of two Black couples. Here, mourners bury the victims at Mount Perry Baptist Church in Bishop, Georgia.

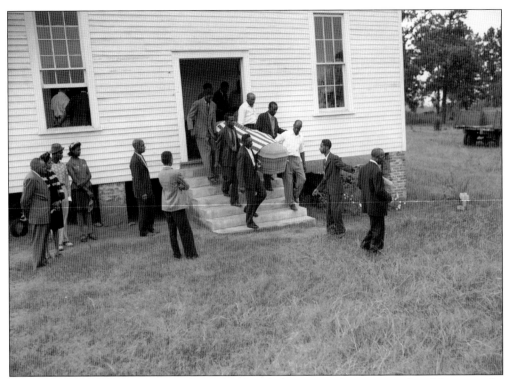

Mourners carry the bodies of veteran George Dorsey to a nearby gravesite. Loy Harrison, the victim's White employer, was the only person to testify to the FBI regarding the lynching of the Dorsey-Malcom couples. He stated that he witnessed them die brutally to 60 bullets fired by an angry mob of masked men. The case was never solved.

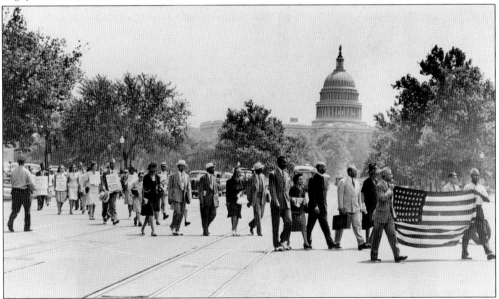

Hoping to seek justice for the Dorsey-Malcom victims and to bring attention to murdered veterans and voters in Georgia amid the gubernatorial election, African Americans marched on the nation's capital.

On August 6, 1946, a 17-year-old Martin Luther King Jr. opined a letter to the editor of the *Atlanta Constitution* expressing his position on the lynching of Mario Snipes and the Dorsey-Malcolm couples killed by mob violence. (Newspapers.com.)

Kick Up Dust

Editor Constitution: I often find when decent treatment for the Negro is urged, a certain class of people hurry to raise the scarecrow of social mingling and intermarriage. These questions have nothing to do with the case. And most people who kick up this kind of dust know that it is simple dust to obscure the real question of rights and opportunities. It is fair to remember that almost the total of race mixture in America has come, not at Negro initiative, but by the acts of those very white men who talk loudest of race purity. We aren't eager to marry white girls, and we would like to have our own girls left alone by both white toughs and white aristocrats.

We want and are entitled to the basic rights and opportunities of American citizens: The right to earn a living at work for which we are fitted by training and ability; equal opportunities in education, health, recreation, and similar public services; the right to vote; equality before the law; some of the same courtesy and good manners that we ourselves bring to all human relations.

M. L. KING, JR.
Morehouse College

Martin Luther King Jr. wrote, "We want and are entitled to the basic rights and opportunities of American citizens: the right to earn a living at work . . . equal opportunities in education, health, recreation, and similar public services; the right to vote; equality before the law; some of the same courtesy and good manners that we ourselves bring to all human relations." (Morehouse College.)

$12,500.00 REWARD!

Rewards totaling $12,500.00 have been offered for information leading to the arrest and conviction of persons involved in the killing of 4 Negroes in Walton County on July 25, 1946.

All Information Will Be Kept Confidential

— CONTACT —
FEDERAL BUREAU OF INVESTIGATION
Telephone WAlnut 3605 Atlanta, Ga.
— OR —
GEORGIA BUREAU OF INVESTIGATION
Telephone WAlnut 5333 Atlanta, Ga.

The FBI offered a $12,500 reward for information leading to the arrest and conviction of individuals involved in the murder of the Dorsey-Malcolm couples near the Moore's–Ford bridge in Morrow, Georgia. Two weeks after the lynching of the Walton County couples, the nation's first neo-Nazi political party, the Columbians, was formed in Atlanta, Georgia. Pictured below, Homer Loomis Jr. (left) and Emory Bryant (right) led the short-lived organization. Loomis is wearing the group's uniform: black tie, khaki pants, and khaki shirts bearing the arm patch of a red lightning bolt, an image derived from the Gestapo, the secret police of Nazi Germany. (Left, Blackpast.org; below, Georgia State University Library Archives.)

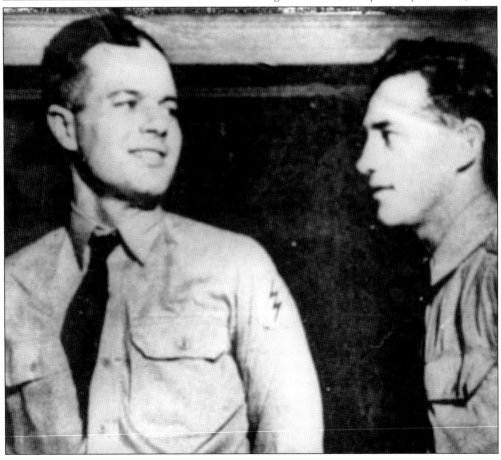

An Atlanta newspaper announced the Columbian's incorporation to form a political party and to create voter unity amongst "all White American citizens who are adherents of the true American spirit." The Fulton County Superior Court issued the charter on August 16, 1946, and was filed with the Georgia secretary of state. (Newspapers.com.)

Columbians Incorporate For Vote Unity

The State of Georgia yesterday granted a charter to an organization known as Columbians, Inc., described by its incorporators as a political organization designed to "create voting soldiarity among all white American citizens who are adherents of the true American spirit."

The charter was approved in Fulton Superior Court and filed shortly afterward with the Secretary of State.

Emory Burke, of 1486 Marbut Ave., S. E., who said he was "on matters of policy the sole authority within the organization," said the Columbians "repudiate the un-American ideas of the melting pot."

Members of the Columbians are photographed marching in Midtown Atlanta carrying placards while demonstrating their opposition to the NAACP. (Associated Press.)

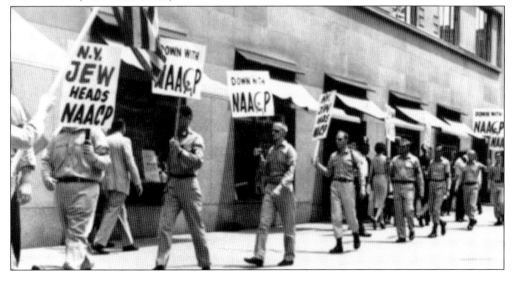

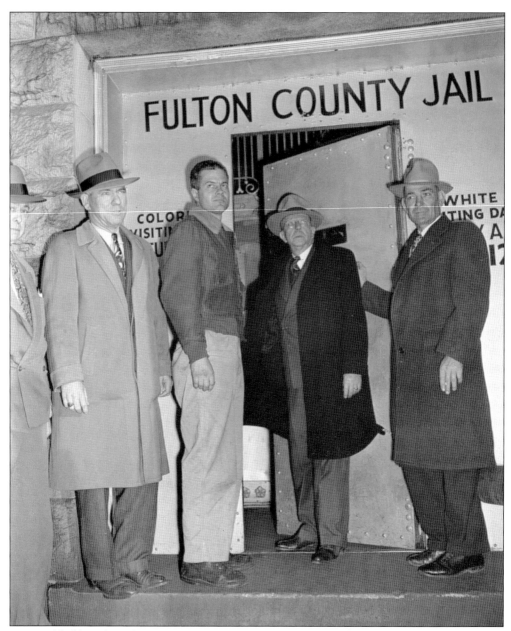

In a trial held at the Fulton County Superior Court in Atlanta, Homer Loomis Jr. and Emory Burke were found guilty of inciting a riot and usurpation of the police force in 1947. Member Ira Jett was also convicted of possessing dynamite. It was believed the explosives were to be used against Black families residing on Ashby Street, now Joseph E. Lowery Boulevard. The Columbian members were sentenced to a year of hard labor and jail time for each charge. (Associated Press.)

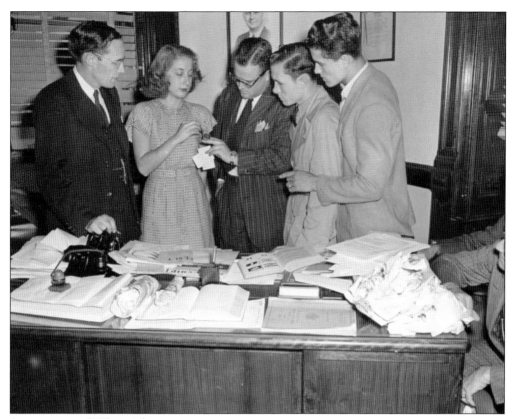

A core group of White Atlantans belonging to the Non-Sectarian Anti-Nazi League (NAZL), worked to dismantle the hate group, the Columbians, Inc. Two former Columbian members, Ralph Childers (right) and Lanier Waller (second from right), and undercover agent of the NAZL, Renee Fruchtbaum (second from left) are pictured with Georgia assistant district attorney Dan Duke (center), who referred to the Columbians as "juvenile delinquents of the Klan." (Associated Press.)

Unbeknownst to the leaders and members of the Columbians, Renee Fruchtbaum was an agent of the Neo-Sectarian Anti-Nazi League who infiltrated the neo-Nazi political party to seek an arrest and conviction of the leaders. Going by the alias Renee Forrest, she served as secretary for the Columbians and exposed incriminating documents to the assistant district attorney Dan Duke. (Newspapers.com.)

EXPOSE AUTHOR ALSO ON INSIDE

Agent and Girl Spy Join Columbian Inner Circle

Recommended by a person now under indictment for sedition, a New York undercover agent was welcomed into the inner circle of the Columbians here, he told State and local officers yesterday.

From his vantage point, this operator for the Anti-Nazi League was able to place a New York girl in the Columbians as a secretary. Never suspecting her as a spy, the Columbians recommended her as a "disciple" to help organize a branch in Indiana, she said.

And an author who exposed hate organizations in the South mingled freely with Columbians as a "fellow member" and carried his findings to the State Attorney General's office.

Mario Buzzi said he played his final role as a secret operator for the Anti-Nazi League when he gathered information on the Columbians. Since newspapers photographed him and since books have mentioned him, he is no longer useful as a secret operative, he said. Miss Renee Forest, serving as a secretary, was able to obtain for law enforcement officials records of the Columbians. She also used a microscopic camera.

The author joining in the probe was Stetson Kennedy, who wrote "Southern Exposure."

RENEE FORREST.
Undercover Girl.

Jones Discounts

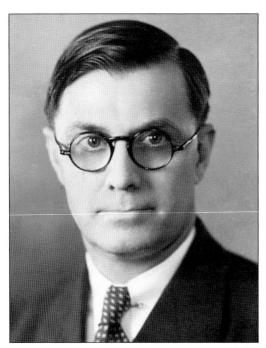

In December 1946, Gov. Eugene Talmadge (left) died after winning the gubernatorial race. With the Georgia General Assembly not certifying who was the new governor, three people claimed the governorship: Ellis Arnall, the outgoing governor; Melvin Thompson, the elected lieutenant governor; and Herman Talmadge, Eugene's son who was a secret write-in candidate.

The "three governors controversy" became one of the great political spectacles in American political history, including journalists discovering evidence of voting fraud allowing Herman Talmadge (below) to be appointed governor by the General Assembly. Finally, the Supreme Court settled the dispute and ruled in favor of Thompson. Herman Talmadge ran against Thompson in 1948 and won. Talmadge served 26 months of his father's term and was reelected to serve a full term in 1950.

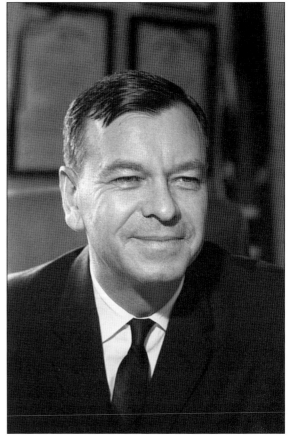

Golden Lamar Howard allowed a journalist to photograph his battered face after he was accosted and beaten by Tom and James Verner of Walton County for testifying before a federal grand jury in the Moore's Ford lynching, which occurred the week following the Democratic gubernatorial election in 1946. (Associated Press.)

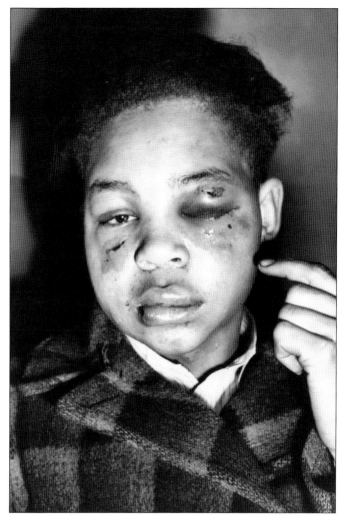

As assistant attorney general of Georgia, Dan Duke argued to revoke the Ku Klux Klan's state-issued charter. He maintained the Klan systematically worked to disenfranchise voters and to "violate the rights of Georgia citizens guaranteed under the Constitution of the state and of the United States." The Klan surrendered its chapter in 1947 after Georgia dropped its charges of murder, flogging, and false arrest against the terrorist organization.

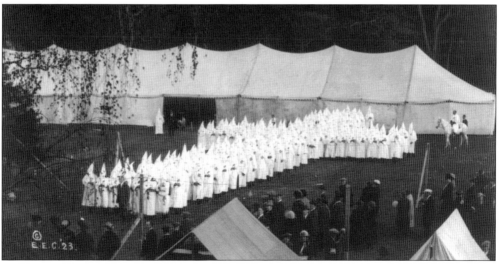

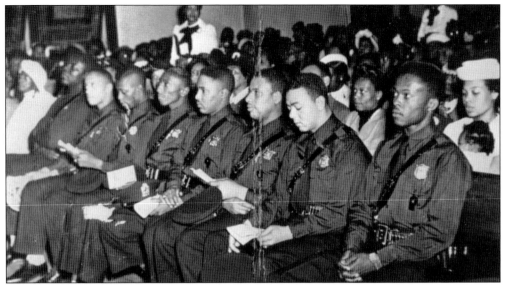

Atlanta Black civic and business leaders brokered a deal with Mayor William B. Hartsfield to hire Black police officers and improve Black neighborhoods in return for securing 10,000 registered voters for the forthcoming mayoral election. The community leaders exceeded the mayor's expectations by registering more than 21,000 Black voters in less than two months in 1946. In 1948, eight African American men integrated the City of Atlanta Police.

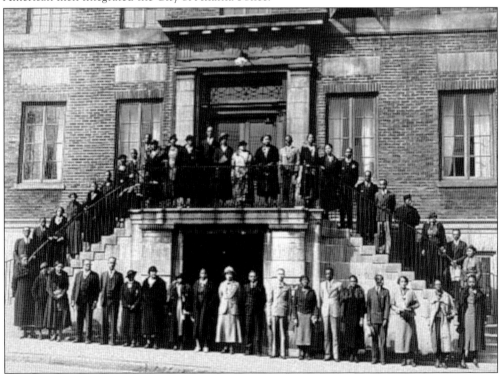

Black Georgians actualized the power of their vote. On July 7, 1949, a bipartisan political organization, Atlanta Negro Voters League, was established by attorney A.T. Walden and Grand Master of the Prince Hall Masons of Georgia John Wesley Dobbs. Pictured are members of the organization.

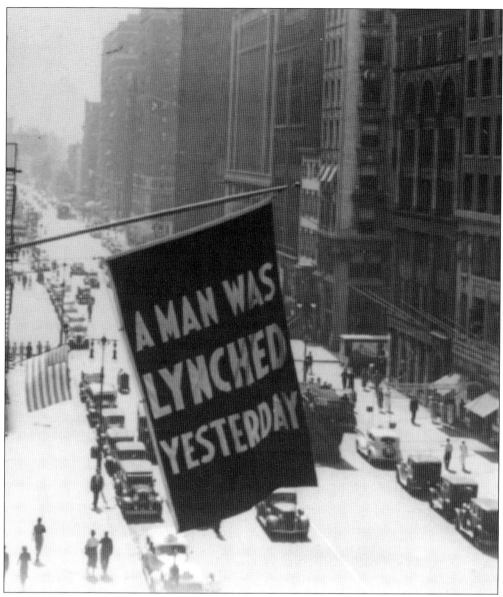

Atlanta-born NAACP national leader Walter White convinced President Truman to pressure Congress to support passing anti-lynching legislation and to integrate the military, which was announced during the 1948 Democratic National Convention (DNC). In opposition to Pres. Truman's support of civil rights and anti-Semitic and anti-Catholic acts, Southern Democrats pulled out of the DNC and formed the States' Rights Political Party called the "Dixiecrats." Pictured is a flag bearing the words "A Man Was Lynched Yesterday" hanging outside of the national NAACP's headquarters in New York City, where Atlanta University graduates James Weldon Johnson and Walter White both served as executive secretary. After more than 200 attempts and more than 100 years of pursuit, the Emmett Till Antilynching Act was signed by US president Joe Biden in 2022.

Southern Democrats formed the States' Rights Political Party in 1948. The political party adopted symbolisms and intimidation tactics from the defunct Atlanta-based neo-Nazi political party, the Columbians. Democratic candidate Harry Truman won the support of Georgia during the presidential election in 1948, but Strom Thurmond, a "Dixiecrat," carried most of the Black Belt states. Pictured is a National States' Rights flag.

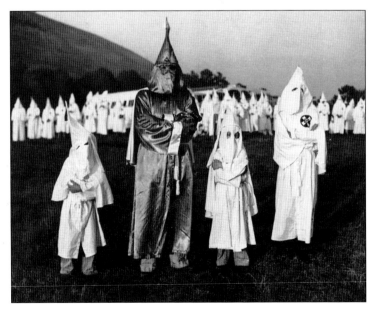

The KKK changed its organization's name after its charter was revoked in 1947. They began initiating thousands of new members in response to the statewide Black voter mobilization campaign. Flanked by three young initiates, Dr. Samuel Green, Grand Dragon of Georgia, is pictured at the top of Stone Mountain with 700 initiates on July 23, 1948, two weeks before the Georgia Democratic primary election.

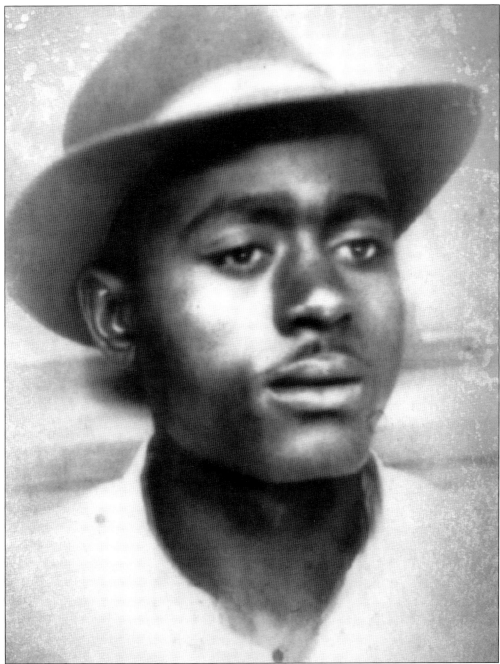

Isaiah Nixon of Alston, Georgia, was killed for voting in the Georgia Democratic primary election on September 8, 1948. J.A. Johnson arrived at Nixon's home and shot him three times. Three days after the presidential election, Johnson was acquitted of killing Nixon on November 5, 1948. (Findagrave.com.)

Isaiah Nixon was a 28-year-old veteran of the US Army. Pictured is his draft registration card. (Ancestry.com.)

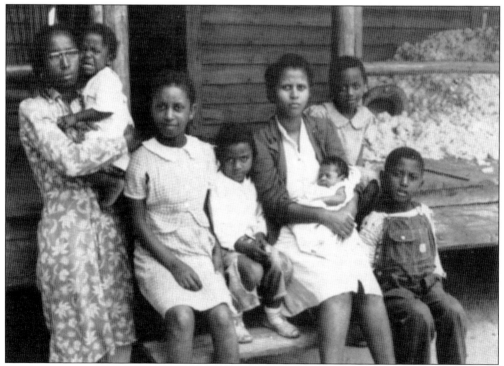

Isaiah Nixon was shot three times in front of his children and wife, Sallie Nixon. As the shots were delivered, Nixon's wife yelled, "Fall, Isaiah, fall!" He died two days later. (*Pittsburg Courier*.)

Four

THE THIRD WAVE
JIM CROW MUST GO, 1960–2010

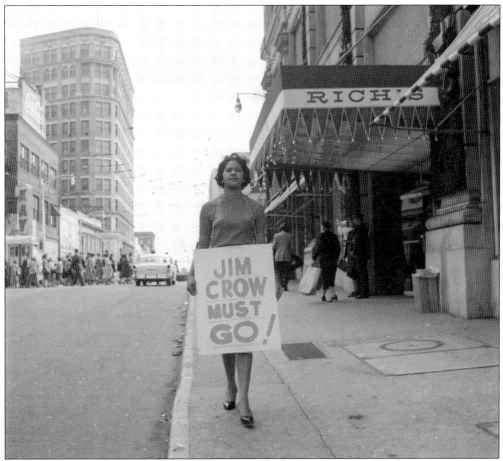

On February 1, 1960, four North Carolina A&T students staged a sit-in at a segregated lunch counter in Greensboro, North Carolina. The students' emotional fortitude and physical restraint captured by the lens of reporters exposed a new generation of young adults to nonviolent direct activism. Inspired by other college students attending historically Black colleges across the United States, Atlanta University Center (AUC) students mobilized to launch a series of demonstrations to end legalized segregation in public facilities. Soon, they would push for voting rights and to destroy Jim Crow laws and customs. (The Herndon Home Museum.)

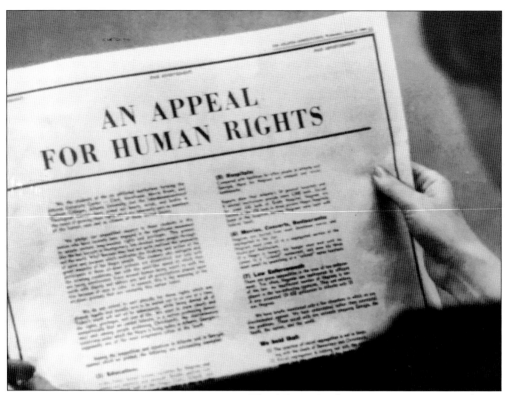

The Atlanta Student Movement was ignited by the publication of "An Appeal for Human Rights," presented as a paid full-page ad in the Atlanta Constitution, Atlanta Journal, and Atlanta Daily World on March 9, 1960. (Preserve Black Atlanta). Student government leaders, representing Atlanta University, Clark College, Morehouse College, Spelman College, Morris Brown College, and the Interdenominational Theological Center, demonstrated their solidarity for civil, human, and voting rights by signing their names to the manifesto. (Associated Press.)

"An Appeal for Human Rights" was written by Roslyn Pope, the Student Government Association president of Spelman College. Signed by AUC student leaders, she wrote, "We do not intend to wait placidly for those rights, which are already legally and morally ours to be meted out to us one at a time. Today's youth will not sit by submissively while being denied all of the rights, privileges, and joys of life." The demands in the 1960 manifesto articulated the tenets of the modern civil rights movement. (Preserve Black Atlanta.)

"An Appeal for Human Rights" was published in the *Atlanta Constitution*, *Atlanta Journal*, and *Atlanta Daily World* on March 9, 1960. Voting was one of the demands listed by the students as a civil and human right.

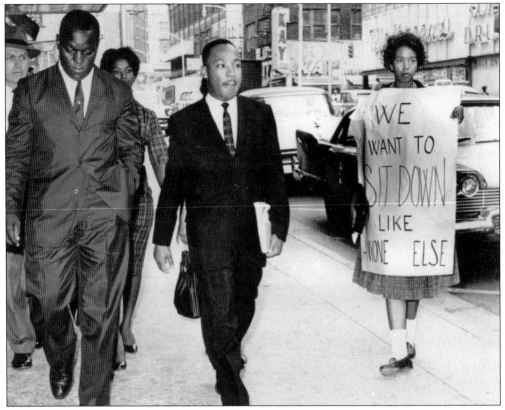

Participating in a "Jail-No-Bail" demonstration, Dr. Martin Luther King Jr. and three college students—Lonnie King, no relation (left); Marilyn Price (far left); and Blondine Dixon (obscured)—are escorted to a police car. The four were arrested for attempting to integrate a Rich's department store restaurant on October 19, 1960. Participating alongside other picketers is Ida Rose McCree. Nearly 50 additional students were arrested for violating Georgia's segregation laws. (Associated Press.)

Due to the arrest at Rich's, Dr. King was sentenced to four months of hard labor at Reidsville State Penitentiary for violating probation for an earlier traffic offense. After being shackled and bound to a prison floor for eight days, he was released after his attorney Donald L. Hollowell, Attorney General Robert Kennedy, and presidential candidate Sen. John F. Kennedy intervened. (Associated Press.)

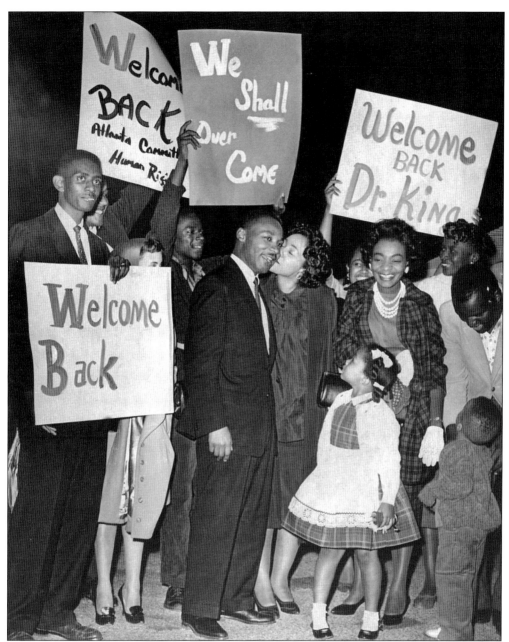

In 1960, The AUC student "Jail without Bail" campaign caught national attention two weeks before the presidential election as Democratic presidential candidate John Kennedy and Attorney General Robert Kennedy intervened to release Dr. King from prison. Consequently, most African Americans cast their vote for John F. Kennedy and switched in large numbers from the Republican to the Democratic Party. Surrounded by AUC students and family, Dr. King receives a welcoming kiss from his wife after being released from Reidsville State Prison on October 27, 1960. (Associated Press.).

Student Nonviolent Coordinating Committee (SNCC) was formed in response to student-led sit-ins across the United States in 1960. Ella Baker, secretary of the Southern Christian Leadership Conference (SCLC), recognized the potential of student activism. SNCC established its headquarters in Atlanta, Georgia. Here, Baker speaks during a press conference with actress Ruby Dee. (Associated Press.)

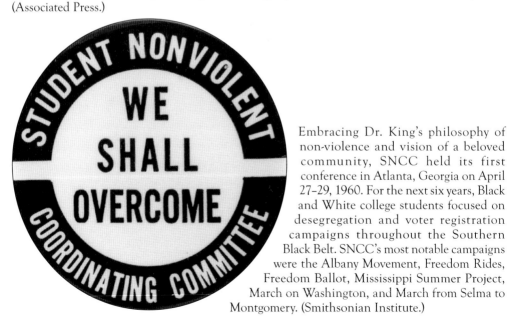

Embracing Dr. King's philosophy of non-violence and vision of a beloved community, SNCC held its first conference in Atlanta, Georgia on April 27–29, 1960. For the next six years, Black and White college students focused on desegregation and voter registration campaigns throughout the Southern Black Belt. SNCC's most notable campaigns were the Albany Movement, Freedom Rides, Freedom Ballot, Mississippi Summer Project, March on Washington, and March from Selma to Montgomery. (Smithsonian Institute.)

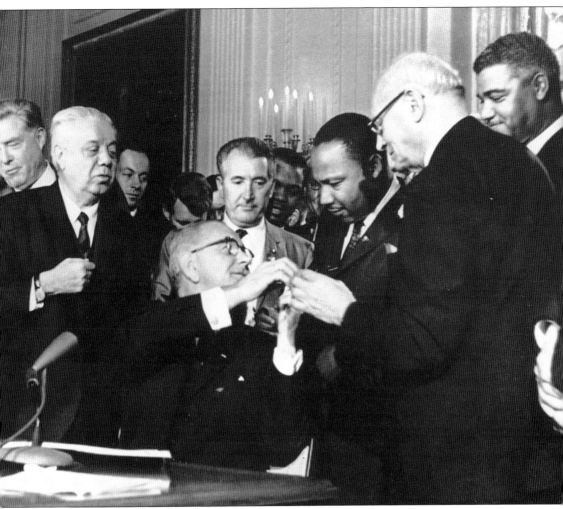

A voter registration campaign organized by CORE and Atlanta-based civic organizations SNCC and SCLC led to the passage of the Civil Rights Act of 1964. The Freedom Summer campaign in Mississippi established the Mississippi Freedom Democratic Party and freedom schools to allow for full participation and representation at the Democratic National Committee. Pictured, President Johnson presents Dr. King with the pen used during the signing of the act. (Associated Press.)

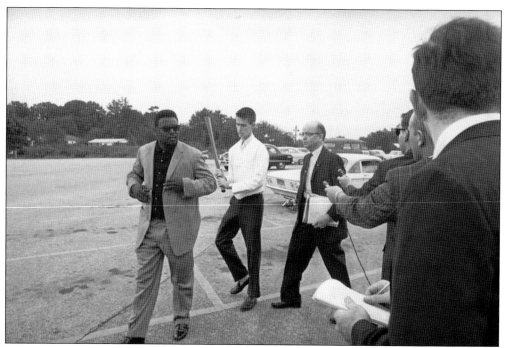

Testing the Civil Rights Act of 1964, Revs. George Willis Jr., Woodrow T. Lewis, and Albert L. Dunn attempted to integrate the Pickrick Restaurant, owned by staunch segregationist Lester Maddox. The three men were denied service and shoved out of the restaurant. A photojournalist captured Rev. George Willis Jr. walking to his car, followed by Maddox, pointing a short pistol, and his son, holding an ax handle. (Associated Press.)

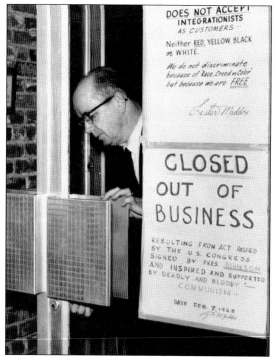

In a unanimous decision, a federal court ruled in *Willis, et. al v. Pickrick Restaurant* that private businesses cannot practice overt racial discrimination in public accommodations. Lester Maddox of the Pickrick Restaurant was given 20 days to begin serving all customers regardless of race or color. He refused to comply. Maddox is pictured closing his restaurant on February 7, 1965, after being fined $200 a day for failing to integrate his establishment. (Associated Press.)

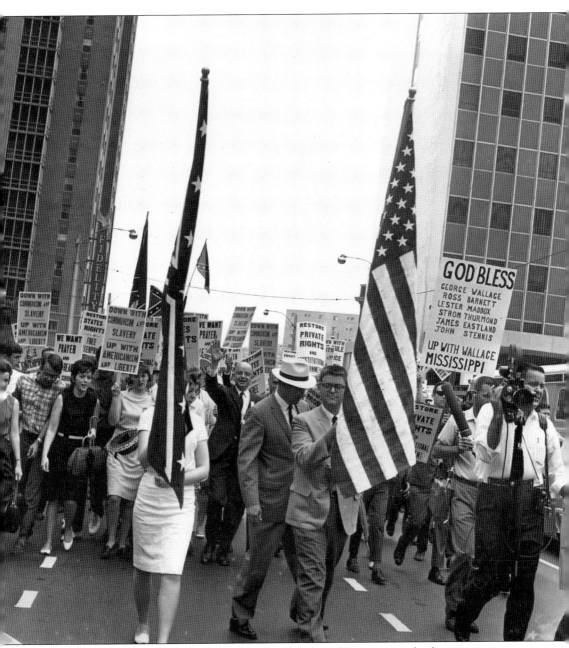

On April 25, 1965, two months after being forced to shut down his restaurant for denying service to African Americans, Lester Maddox led a crowd of more than 1,000 protesters through downtown Atlanta, calling for restoring private rights. He was elected as governor of Georgia in 1966. (Associated Press.)

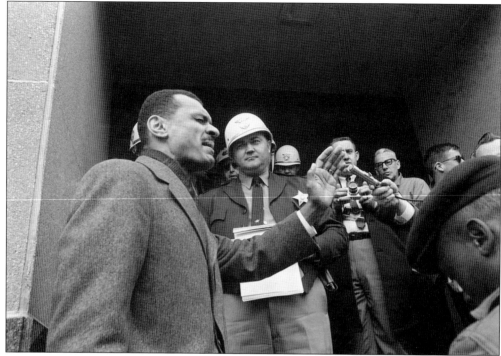

In January 1965, SCLC organized a massive direct-action voting registration campaign in Selma, Alabama, a grassroots initiative organized initially by field organizers of SNCC since 1963. With SCLC taking the lead on mobilizing citizens to register to vote, the two Atlanta-based organizations worked conjointly in Selma to secure voting for African Americans. Here, SCLC director of affiliates Rev. C.T. Vivian of Atlanta, Georgia, leads a group of demonstrators in prayer as they attempt to enter the Dallas County Courthouse to register to vote. Deputy Sheriff Jim Clark struck Reverend Vivian during a nationally televised program. (Associated Press.)

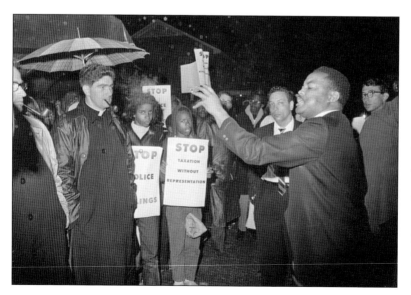

On February 13, 1965, SCLC field director Hosea Williams of Atlanta, Georgia, informs a crowd of demonstrators in Selma that "come hell or high water," they will march to the courthouse. (Associated Press.)

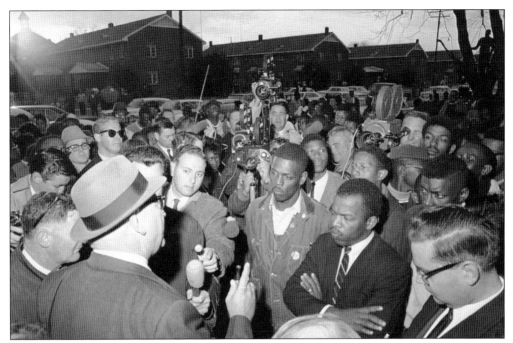

SNCC chairperson John Lewis led a group of 200 young demonstrators through the streets of Selma on February 23, 1965. The group returned to a church after public safety director Wilson Baker (left) warned of the dangers of White opposition and marching at night. (Associated Press.)

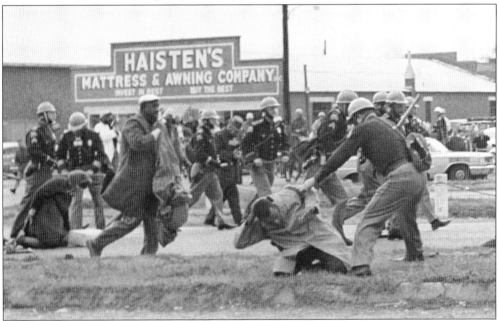

During the first march attempt from Selma to Montgomery, SCLC field director Hosea Williams and SNCC chairperson John Lewis led more than 500 marchers across the Edmund Pettis Bridge on March 7, 1965. The crowd was met with bloodshed as state troopers and police officers swung billy clubs and trampled and tear-gassed male and female protesters. Lewis is pictured receiving blows to the head and body. (Associated Press.)

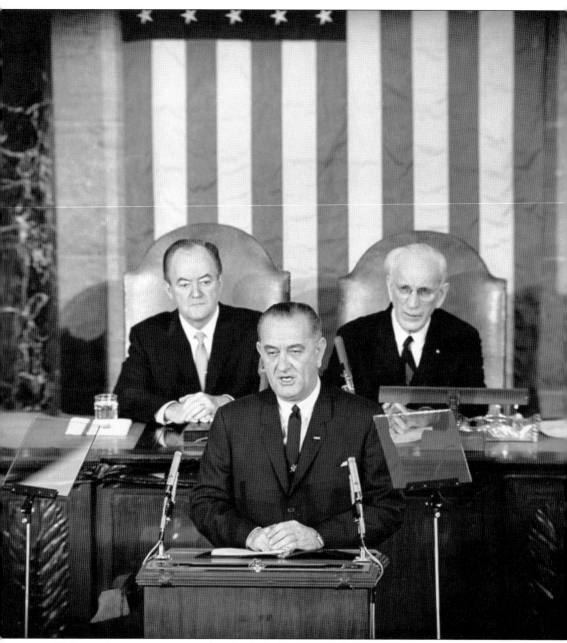

With marchers experiencing jail, police brutality, and fatalities, Pres. Lyndon B. Johnson presented a draft of the Voting Rights Act before Congress on March 15, 1965, during a televised program before the nation. In his "American Promise" speech, he closed with the statement "It's all of us who must overcome the cripple legacy of bigotry and justice. And-we-shall-overcome." (Associated Press.)

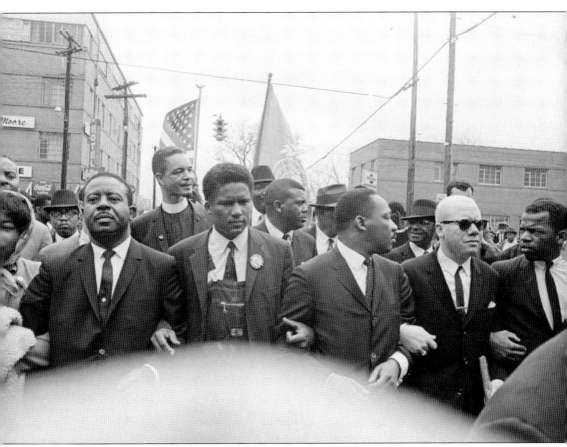

Georgians were instrumental in the March from Selma to Montgomery demonstrations and in securing the Voting Rights Act of 1965. Representing the Southern Christian Leadership Conference (SCLC) and the Student Nonviolent Coordinating Committee (SNCC) located in Atlanta, Georgia, are, from left to right, Dorothy Cotton (SCLC), Rev. Ralph David Abernathy (SCLC), James Forman (SNCC), Dr. Martin Luther King Jr. (SCLC), Jesse Douglass (SNCC), and John Lewis (SNCC). (Associated Press.)

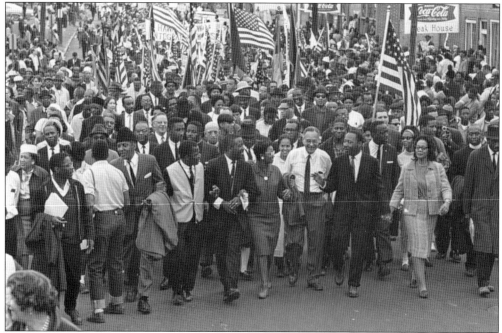

Photographed during the final stretch of the 54-mile march from Selma to Montgomery are SNCC and SCLC officers from Georgia leading 25,000 demonstrators to the Alabama State Capitol on March 25, 1965. Pictured to the far left are Bernard Lee (SCLC), Bayard Ruston (AFL-CIO), John Lewis (SNCC), Rev. Ralph David Abernathy (SCLC), Juanita Abernathy, Ralph Bunche (Nobel Peace Prize laureate), Dr. Martin Luther King Jr. (SCLC), and Coretta Scott King (SCLC). (Associated Press.)

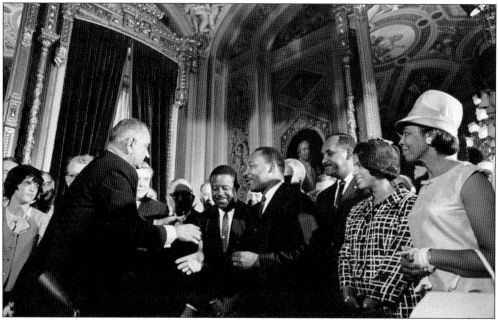

Pres. Lyndon B. Johnson stands to shake Dr. King's hand and presents him with a pen after signing the Voting Rights Act on August 6, 1965. (Associated Press.)

Following the passage of the Voting Rights Act of 1965, eleven African Americans joined the Georgia General Assembly in 1966. Leroy Johnson was the first African American elected to the Georgia General Assembly since W.H. Rogers of McIntosh resigned his seat in 1907. Johnson served as a state senator from 1963 to 1975. (Associated Press.)

Grace Towns Hamilton was elected as the first African American female Georgia legislator and the first African American woman to serve as a state legislator in the Southeast. She was one of six African Americans from Atlanta elected to join the General Assembly. (Associated Press.)

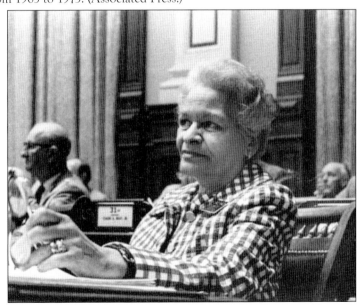

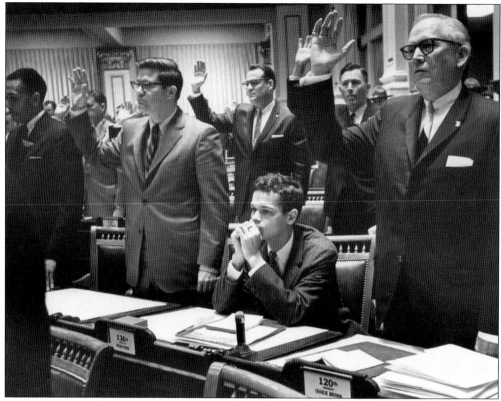

Julian Bond was banned on January 10, 1966, from taking his seat in the Georgia House of Representatives because he supported SNCC's anti-war stance on Vietnam. (Associated Press.)

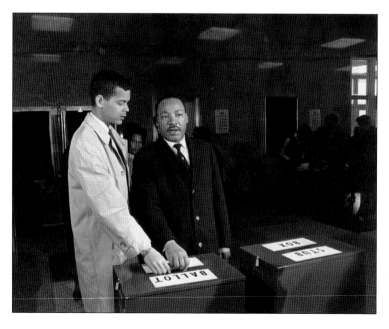

On February 23, 1966, Dr. King and Julian Bond are photographed as they cast ballots together to return Bond to his District 136 seat in the Georgia House of Representatives. In the case of *Bond v. Floyd*, the US Supreme Court, on December 5, 1966, granted Julian Bond permission to take his seat in the Georgia House of Representatives. (Associated Press.)

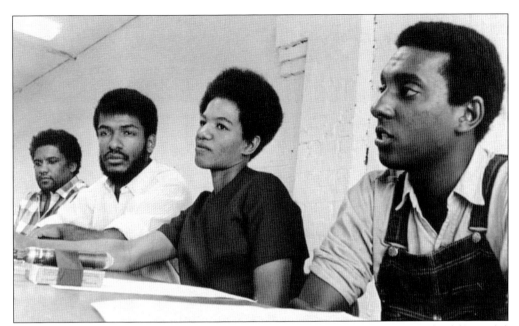

The philosophy and direction of SNCC shifted in 1966 when Stokely Carmichael (far right) succeeded John Lewis as chairperson, Ruby Doris Smith Robinson (second from right) replaced James Forman (left) as executive secretary, and Cleveland Sanders (third from right) was elected as program director. The rallying cry of SNCC went from "Freedom Now!" to "Black Power!" as members advocated for cultural institutions, economic autonomy, and Black political representation.

During the same year, SNCC ignited a citywide Tenants' Rights Movement called "the Atlanta Project," It campaigned to reelect state legislator Julian Bond who was unseated for supporting SNCC's position against the Vietnam War. During an Atlanta Project rally, Willie "Mukasa" Ricks, called for "Black Power." The slogan was coined by Ricks but popularized by Stokely Carmichael. (Herndon Home Museum.)

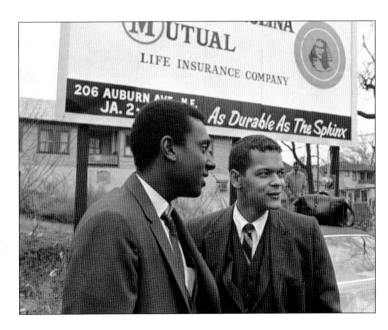

115

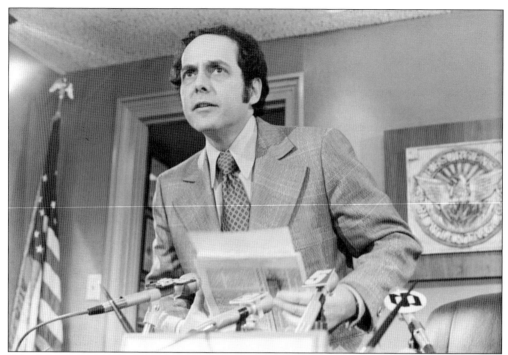

Fifty-five years after the lynching of Leo Frank, a Jewish factory superintendent, in 1915, Sam Massell was elected as the first Jewish mayor of Atlanta, Georgia. He served as mayor from 1970 to 1974. (Kenan Research Center, Atlanta History Center.)

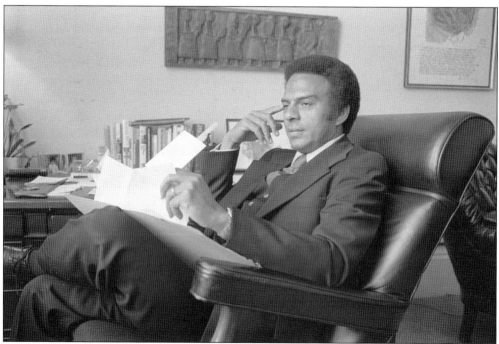

In 1972, Andrew Young became the first African American since Reconstruction to become a member of Congress from the South.

Maynard Jackson was elected mayor of Atlanta in 1973 and became the first African American mayor of a major southern city. He served three terms from 1974 to 1982 and from 1990 to 1994.

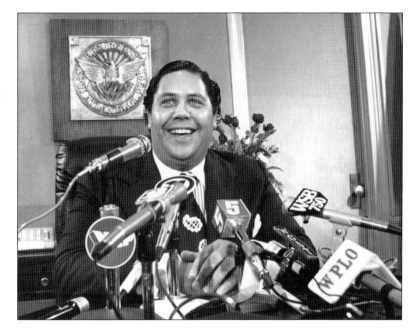

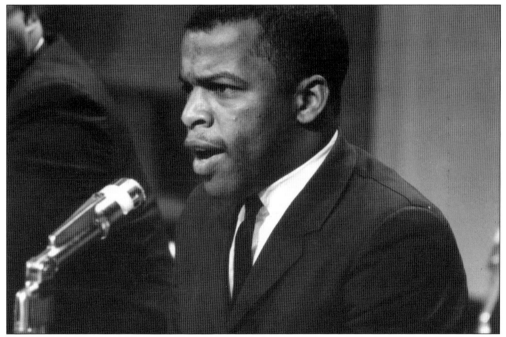

Coining "Good Trouble," John Lewis committed 60 years to securing and protecting voting rights. He was a speaker at the 1963 March on Washington, and leader of the "Blood Sunday" march from Selma to Montgomery that caused Pres. Lyndon B. Johnson to sign the Voting Rights Act of 1965. Lewis was elected to Georgia's Fifth Congressional District in 1986 and served until his death in 2020.

Gov. Jimmy Carter was elected as president of the United States in 1976. He was defeated by Ronald Reagan in 1980.

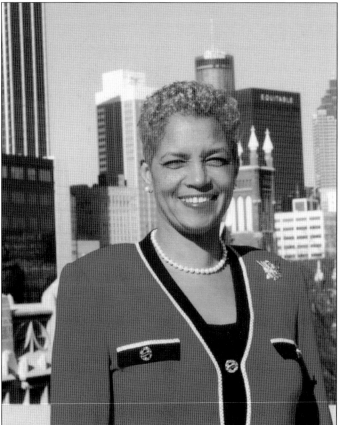

Shirley Franklin became the first woman elected as mayor of Atlanta and of a major southern city. She served for two terms from 2002 to 2010.

Five

THE FOURTH WAVE
A BLUE ISLAND IN A RED SEA
2020–2023

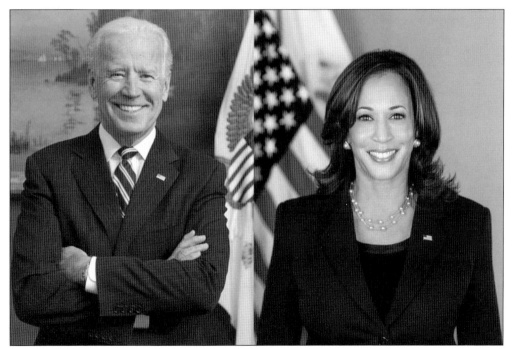

In 2020, history was made when Democratic presidential nominee Joseph Biden and his running mate Kamala Harris won Georgia. It had been 28 years since a Democratic presidential nominee won the state, with Bill Clinton securing a victory in 1992. This political shift was due to massive voter registration and mobilization efforts by numerous BIPOC and women-led organizations determined to change the electoral landscape.

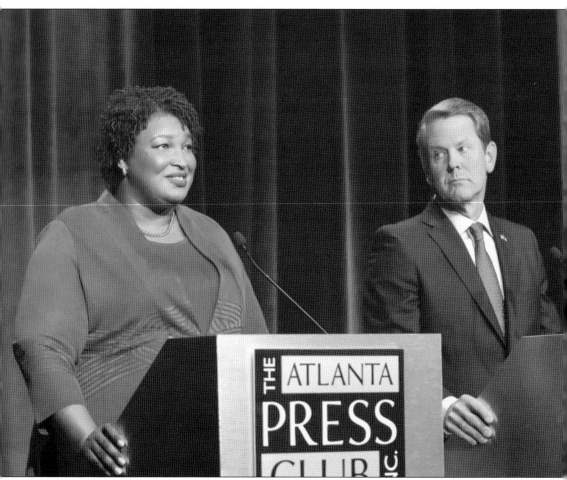

The 2020 election, as it pertains to greater voter turnout and Democratic Party success, had its origins in 2018 with the gubernatorial campaign of then minority leader State Representative Stacey Abrams (left). She believed the demographic changes in Georgia could support a progressive campaign. Her investment in a statewide voter registration and mobilization infrastructure catalyzed a dramatic shift in the Georgia political landscape. Although she lost by 54,000 votes in 2018 to Republican Brian Kemp (right), Abram's campaign changed the political trajectory of Georgia, causing it to become a blue island in a red sea. (Associated Press.)

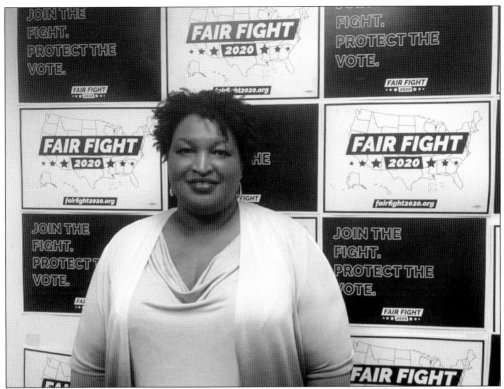

In the aftermath of closely losing the 2018 gubernatorial election, to then–Georgia secretary of state Brian Kemp, under "questionable" conditions, Stacey Abrams established Fair Fight to advocate for fair elections. (New Georgia Project.)

The New Georgia Project, led by Nse Ufot, resulted in over two million newly registered voters for the state of Georgia; many of whom were young, Black, and Latino. (New Georgia Project.)

The 2020 election was unique because it occurred during the COVID-19 pandemic. Using absentee ballots, federal, state, and local officials worked tirelessly to develop innovative strategies to minimize further outbreaks and retain confidence in the electoral process. Democratic and Republican election officials ensured democracy would prevail. Georgia voters resoundingly responded with one of the highest turnouts ever. Pictured is an Athens, Georgia, voter casting an absentee ballot. (Associated Press.)

The year 2020 was indeed historical in Georgia politics. Beyond the victory enjoyed by Vice President Biden, Jon Ossoff defeated US senator David Perdue and became the first Jewish American to represent the state. Joining him was Raphael Warnock, who in defeating US senator Kelly Loeffler, served the remaining term of Sen. Johnny Isakson and became the first African American to represent Georgia in the US Senate. (Associated Press.)

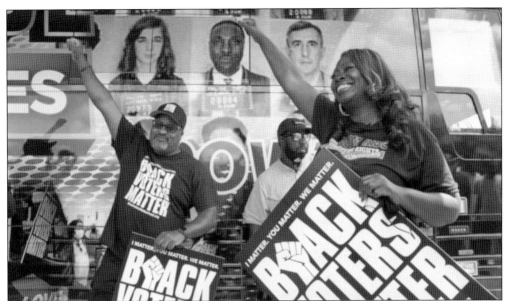

Pictured is Cliff Albright (left) and LaTasha Brown (right), cofounders of Black Voters Matter. (Black Voters Matter.)

Other evidence of the sweeping political change across the state in 2020 was the emergence of Black political leadership in traditional Republican counties with Nicole Love Hendrickson and Lisa Cupid becoming the first African American female Democrats to lead the Gwinnett and Cobb County commissions. BIPOC and women-led organizations were key in organizing the vote throughout Georgia. Pictured is Terri Sewell holding a Black Voters Matter placard. (Black Voters Matter.)

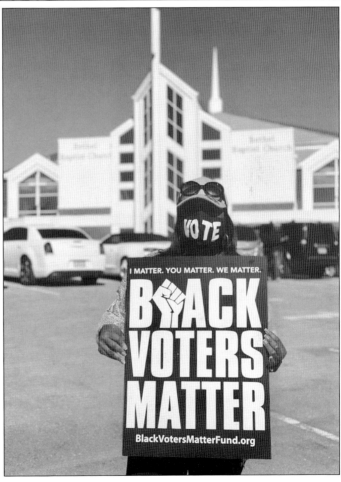

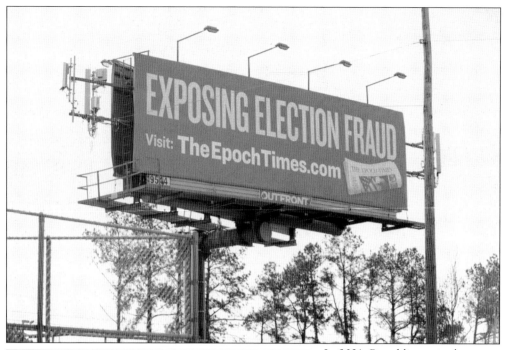

In 2021, Republicans in the Georgia General Assembly sought to investigate the 2020 election and sponsor numerous bills to address their concerns. As a result, the legislature, along party lines, passed Senate Bill 202, entitled the Georgia Election Integrity Act. Many progressive, BIPOC organizations saw this as a direct response to the political victories in 2018 and 2020. (Associated Press.)

Even with the passage of Senate Bill 202, many advocacy organizations in 2021 continued to register voters, organize communities, and support candidates who championed their causes. In this photograph, Deborah Scott (left), executive director of Georgia Stand Up, and Dr. Karcheik Sims-Alvarado (right) discuss the history of African American protest for civil and voting rights as part of a voter education campaign headed by Scott's organization.

The 2022 midterm elections were equally memorable with Stacey Abrams and Raphael Warnock leading the Democratic ticket in hopes of finally turning Georgia blue. Abrams was unsuccessful in her second bid to become governor, but Warnock (pictured) was able to secure his reelection by defeating the Republican senate nominee, Herschel Walker. Republican candidates were able to hold on to every state constitutional office and retain power in the Georgia legislature. (Associated Press.)

In August 2023, Georgia made national political news with Fulton County District Attorney Fani Willis indicting former US president Donald Trump and 18 other coconspirators under the Georgia RICO (Racketeer Influenced and Corrupt Organizations) statute claiming they conspired to illegally overturn the 2020 presidential election. (Associated Press.)

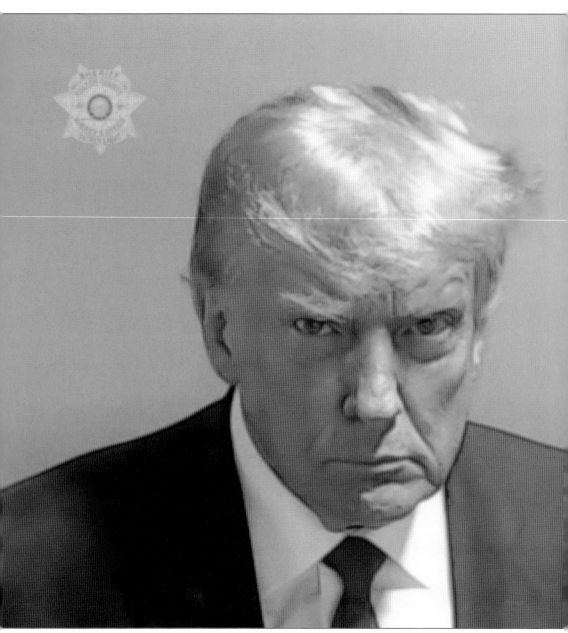

Pictured is former president Donald Trump's mugshot taken at the Fulton County Jail after he turned himself in to be arrested for over 90 charges brought forth by the Fulton County District Attorney's Office. Even amid potential prosecution, Trump is running for the 2024 Republican presidential nomination and leading the polls nationally and in Georgia. His trial and election outcome will be determined after the publication of Images of America: *Georgia and the Power of the Vote*. (Associated Press.)

BIBLIOGRAPHY

Bacote, C.A. "The Negro in Atlanta Politics." *Phylon (1940–1956)* 16, no. 4 (1955): 333-50.
Bacote, Clarence A. "William Finch, Negro Councilman and Political Activities in Atlanta During Early Reconstruction." *The Journal of Negro History* 40, no. 4 (1955): 341-64.
Cimbala, Paul A. *Under the Guardianship of the Nation: The Freedmen's Bureau and the Reconstruction of Georgia, 1865–1870*. Athens: University of Georgia Press, 2003.
Drago, Edmund L. *Black Politicians and Reconstruction in Georgia: A Splendid Failure*. Athens: University of Georgia Press, 1992.
Du Bois, W.E.B, and David Levering Lewis. *Black Reconstruction in America*. New York, NY: the Free Press, 1998.
Du Bois, William Edward Burghardt. *The Freedmen's Bureau*. Netherlands: Atlantic Monthly Company, 1901.
Sims-Alvarado, Karcheik. *Atlanta and the Civil Rights Movement: 1944–1968*. Charleston, SC: Arcadia Publishing, 2017.
Thompson, Mildred. *Reconstruction in Georgia*. New York: Columbia University Press, 1915.

Discover Thousands of Local History Books Featuring Millions of Vintage Images

Arcadia Publishing, the leading local history publisher in the United States, is committed to making history accessible and meaningful through publishing books that celebrate and preserve the heritage of America's people and places.

Find more books like this at
www.arcadiapublishing.com

Search for your hometown history, your old stomping grounds, and even your favorite sports team.

Consistent with our mission to preserve history on a local level, this book was printed in South Carolina on American-made paper and manufactured entirely in the United States. Products carrying the accredited Forest Stewardship Council (FSC) label are printed on 100 percent FSC-certified paper.